IMAGES
of Sports

PHILADELPHIA'S BOXING HERITAGE 1876–1976

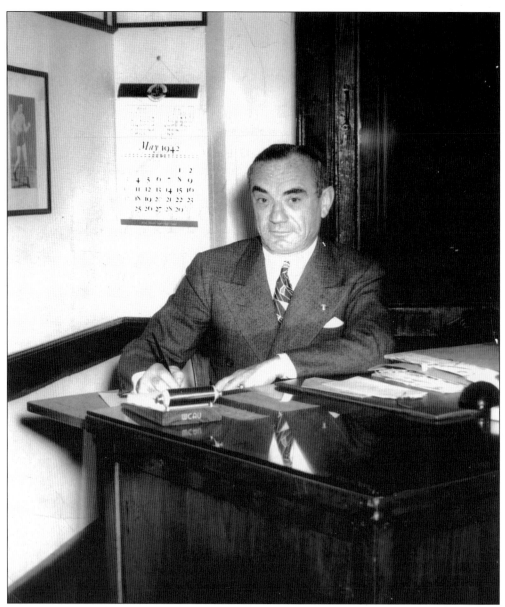

HERMAN TAYLOR. Much credit for the success of local boxing has to go to the promoters, who were great ballyhoo artists and matchmakers. They knew how to build up crosstown rivalries and neighborhood feuds into epic confrontations by dangling matches before the public in the newspapers and closing the deals when the money was right and the public's appetite was at its peak. This has been the case since the days of Jack McGuigan at the National Athletic Club and such legendary impresarios as Herman Taylor, Jimmy Toppi, and Johnny Burns to the present with J. Russell Peltz. (Courtesy Temple University Libraries, Urban Archives.)

IMAGES
of Sports

PHILADELPHIA'S BOXING HERITAGE 1876–1976

Tracy Callis, Chuck Hasson, and Mike DeLisa

ARCADIA
PUBLISHING

Published by Arcadia Publishing
Charleston SC, Chicago IL, Portsmouth NH, San Francisco CA

Printed in the United States of America

Library of Congress Catalog Card Number: 2002110516

For all general information contact Arcadia Publishing at:
Telephone 843-853-2070
Fax 843-853-0044
E-mail sales@arcadiapublishing.com
For customer service and orders:
Toll-Free 1-888-313-2665

Visit us on the Internet at www.arcadiapublishing.com

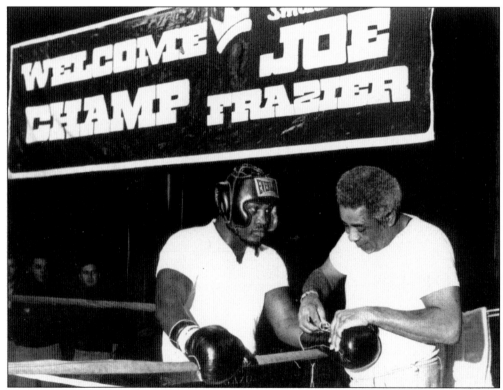

A TOUGH TEAM TO BEAT. Joe Frazier was a Philadelphia fighter from the word go and was always given good advice by his mentor, Yank Durham. A "father-son" bond formed between them when Frazier arrived in Philadelphia as a 16-year-old. The relationship lasted until Durham's untimely death in 1974 from a heart attack. (Courtesy Antiquities of the Prize Ring.)

CONTENTS

ACKNOWLEDGMENTS

The authors express their appreciation to all those who helped in the development of this book: Harry and Raven Shaffer at Antiquities of the Prize Ring (www.antekprizering.com); Evan Towle of the Temple University Libraries, Urban Archives; Joseph Benford of the Free Library of Philadelphia; Stu Saks of the London Publishing Company (the *Ring*); Peltz Boxing Promotions Inc.; George Silvano, son of Jimmy Wilson; Kay Mahoney, daughter of Matt Adgie; Rich Pagano; Joe Cassidy; J.J. Johnston; Kevin Smith; Bob Carson; and the staff of Arcadia Publishing for excellent direction. We also appreciate the assistance and patience of our families.

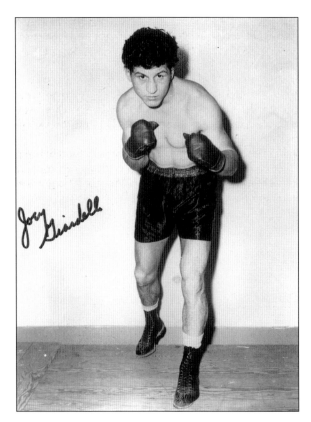

A DETERMINED MAN. Born Carmine Orlando Tilelli in Brooklyn, Joey Giardello fought out of Philadelphia and was a solid puncher and crowd favorite. He began his career in 1948, and he boxed for 11 years before getting a title shot against Gene Fullmer on April 20, 1960, at Bozeman, Montana. The bout ended in a draw after 15 rounds, and Fullmer retained the title. A little over three years later, Giardello achieved his dream of becoming middleweight champion of the world.

INTRODUCTION

Philadelphia, the City of Brotherly Love, has been a beehive of pugilistic activity from its very beginning. The sport has long been in the minds and hearts of its people—from the early predominance by the Irish and English to the shift toward the large number of Jewish participants, followed by the many Italian scrappers and the eventual dominance by black fighters.

The city has produced many champions, top contenders, managers, promoters, and trainers. World-famous athletic clubs, gymnasiums, and fight facilities have been the norm.

Ireland, England, Australia, and America were foremost in matters of pugilism in the early days, and each had its champions. Without a universal system for determining champions, claims were often heard, followed by challenges. Words were hurled back and forth across the oceans. Sometimes, contests were arranged between the "best," sometimes not. The Irish, English, and Australians journeyed to our shores to teach us a lesson. More often than not, they ended up in Philadelphia.

This "willing" disposition of Philadelphia fighters translated into an aggressive, yet clever, game and relentless fighting style that has thrilled fans over the years. They have come to expect—even demand—this type of scintillating mayhem from their combatants. The Philadelphia bouts were big drawing cards because fans were assured of highly intense, rock 'em sock 'em, nonstop action that took the crowds to a fever pitch.

In 1857, Philadelphian Dominick Bradley claimed the world heavyweight prizefighting championship after defeating Sam Rankin of Baltimore in a brutal, early-morning bareknuckle contest in Canada. Although the claim was not universally recognized, much coverage was given by the national sporting press. As usual, Philadelphia was making fight news.

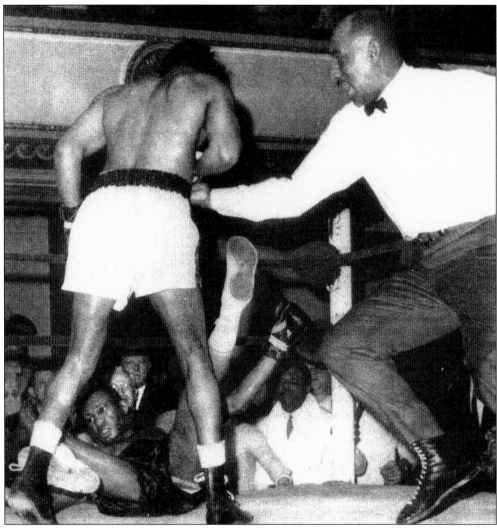

DOWN YOU GO. Stanley "Kitten" Hayward, from Strawberry Mansion, knocks out future welterweight champion Curtis Cokes at the Blue Horizon in the fourth round on May 1, 1964. The bout was shown on national television. Hayward was a top-rated contender, with wins over Emile Griffith, Bennie Briscoe, and other highly ranked contenders.

One

1876–1899

In 1876, a bareknuckle contest involving two Philadelphians-was held for the benefit of gamblers on a barge near Pennsville, New Jersey. The loser, Billy Walker, died from injuries sustained in the battle. The winner, Jimmy Weeden, was incarcerated and died in prison a year later due to fight wounds not properly treated.

Pressure against fighting by legal authorities was so intense that changes had to be made to save it. Thus were born the Philadelphia Rules, in which boxing was to be conducted within the city limits as "sparring contests" of four rounds duration. Later, this was changed to six rounds. Boxers contended for "scientific points."

In no time, the local boxing fraternity had figured ways to get around these rules. Gamblers would choose a report from a specific local newspaper as a way of settling wagers. Any paying customer would automatically become a member. Combatants battled viciously for those scientific points.

In 1879, an Irish immigrant from Philadelphia, John Clark, fought for the world lightweight championship and was beaten by the titleholder, Arthur Chambers, in Canada. Both Chambers and Clark went on to make prizefighting a successful enterprise-in Philadelphia by opening boxing salons in the city and developing local talent.

By the early 20th century, the city had been recognized as one of the leading fight centers of the world for more than 20 years,-and many of its pugilists had national reputations for skill and toughness. Jack Fogarty, Charlie McKeever, Jack Bonner, and Eddie Lenny had unsuccessful but thrilling shots at world titles.

HE KILLED A MAN IN THE RING.
Bareknuckle boxing was illegal in virtually all states of the union. Lightweight "Philadelphia" Jimmy Weeden would learn that to be true in the most tragic of ways. On August 31, 1876, Weeden battered and defeated Billy Walker. When Walker died from injuries sustained during the contest, Weeden was arrested. He was convicted of murder and imprisoned for life at Trenton Penitentiary, where he died after a year. (Courtesy Bob Carson.)

A SIZZLING HITTER. Mike Cleary was born in England but settled in Philadelphia. Many men, including heavyweight champion Jim Corbett, called Cleary one of the hardest hitters ever seen. His first recorded bout in Philadelphia was on January 5, 1875, when he knocked out Lew Chambers in three rounds. In 1878, he knocked out Sam Carr and Harry Hicken. After a couple of fights in 1881, including a draw against Dominick McCaffrey, Cleary traveled America. He returned to Philadelphia in 1886 for a few more bouts.

THE LIGHTWEIGHT CHAMPION. Arthur Chambers, who was born in England, fought John Clark for 136 rounds at Chippewa Falls on March 27, 1879, for the American lightweight championship. He eventually located in Philadelphia and conducted a famous boxing school called Champions' Rest for many years. (Courtesy Antiquities of the Prize Ring.)

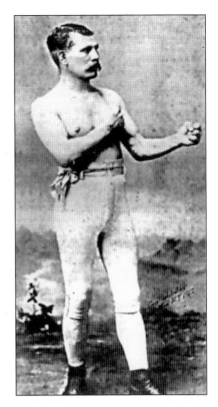

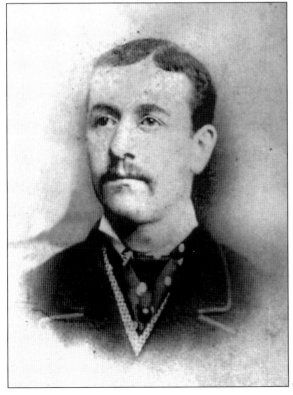

A PROFESSOR OF BOXING. John Clark, born in Ireland, moved to Philadelphia after his lightweight championship bout and conducted his famous Olympic boxing school for many years. (Courtesy Antiquities of the Prize Ring.)

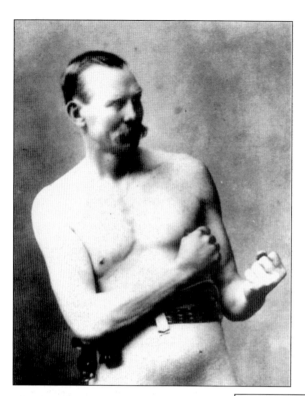

ANOTHER PROFESSOR. Billy McLean was a bareknuckle fighter who became a boxing instructor at his own boxing school in Philadelphia. In his later years, McLean became involved in politics. (Courtesy Antiquities of the Prize Ring.)

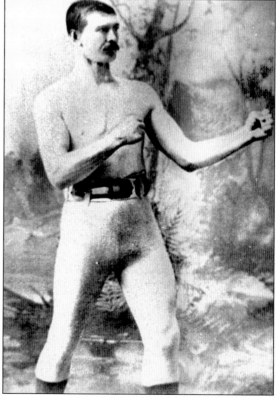

A HITTER MOST DANGEROUS. Pat Killen, a heavyweight from Lansdale, fought from 1883 until 1891. He was a patient fighter with a devastating punch that could take a man out with one blow. Killen was probably a better knockout hitter than John L. Sullivan but was less durable.

SLICK AND QUICK. "Nonpareil" Jack Dempsey made his first appearance in Philadelphia in 1884 for four bouts. He was back again in 1886 for three wins and in 1887 for three more. He finished his Philadelphia bouts with two exhibitions in 1893.

SCRAPPY AND SMART. Middleweight Jack Fogarty fought Jack Dempsey on February 3, 1886, in New York for the world middleweight championship. During his career, Fogarty also managed the Ariel Athletic Club in Philadelphia for several years. (Courtesy Antiquities of the Prize Ring.)

GREASED LIGHTNING. Jack McAuliffe, the lightweight champion, came to Philadelphia with his fists flailing in 1885 and knocked out Buck McKenna in two rounds on December 7. On July 31, 1886, he scored his greatest win in the Quaker City when he knocked out tough Philadelphian Charles "Bull" McCarthy in three rounds. In 1887, McAuliffe boxed only exhibitions here. He then departed but returned in 1893 and boxed a series of exhibitions.

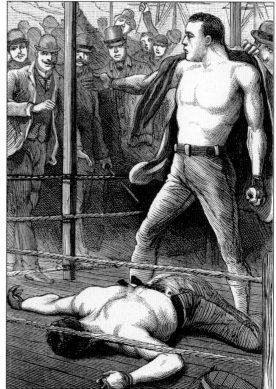

THE ENGLISH CHAMPION PREVAILS. Philadelphian Jimmy Mitchell (down) met the English lightweight champion, Jem Carney, on June 18, 1887, on a barge in Long Island Sound. Mitchell lost in the 11th round.

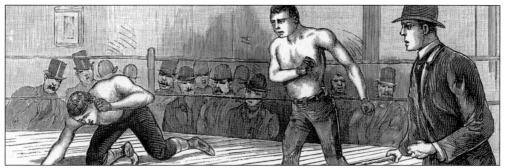

WALTON FIGHTS FOR THE FEATHERWEIGHT CHAMPIONSHIP. Philadelphian Harry Walton (left) met Cal McCarthy for the American featherweight championship on January 25, 1889, in Trenton. McCarthy knocked him out in five rounds.

FAREWELL BENEFIT

WILL BE TENDERED

JOHN H. CLARK,

By his numerous friends previous to his leaving Philadelphia,

Large Money Prizes

will be given to the best light weight Boxer and the best sentimental Singer each contest to be decided by the show of hands from the audience, this will be the event of the Olympic Season.

The Great Feature

will be a set to between the two acknowledged Champion Boxers,

............ of New York

AND

JOHN H. CLARK of Philadelphia

February 8th.

General Admission 50 Cts.

CLARK'S OLYMPIC, 8TH & VINE.

A TICKET FOR THE FAREWELL BENEFIT. John Clark and Mike Donovan boxed an exhibition on February 8 at the Olympic Athletic Club *c.* 1889. Clark was leaving Philadelphia for a boxing tour of America.

15

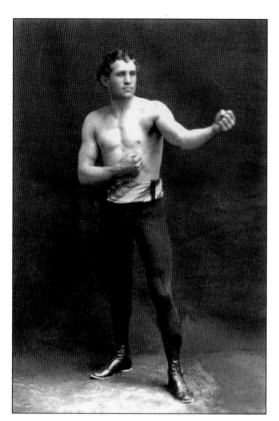

A Tough Customer. Owen Ziegler, an outstanding lightweight of the 1890s, was a regular feature in Philadelphia. During his career he defeated such men as Charlie McKeever, Dal Hawkins, Jack Bennett, and Jerome Quigley. (Courtesy Antiquities of the Prize Ring.)

Matt McCarthy Fights for the American Title. Matt McCarthy, an up-and-coming featherweight from Philadelphia, fought from the late 1880s through the early 1890s. He tangled with Cal McCarthy (right) for the American featherweight championship on April 5, 1889, at Long Island. Cal stopped him in round six.

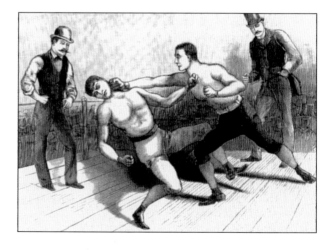

16

A Wonderful Boxer. George Dixon was a hot item in Philadelphia boxing during 1892 and 1893. The future all-time great bantamweight and featherweight boxed in Philadelphia 19 times in 1892, mostly exhibitions, and 13 times in 1893. He appeared a few times afterward, but these were his busy years here. (Courtesy Antiquities of the Prize Ring.)

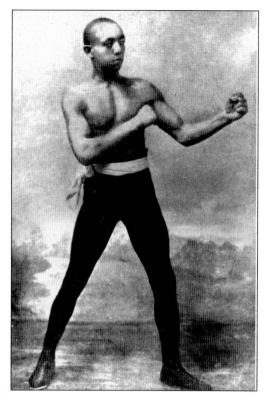

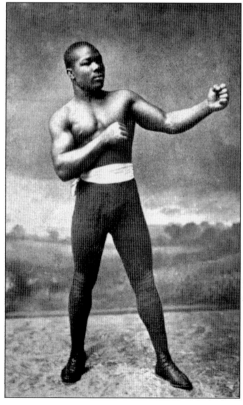

Dynamite in a Small Package. Joe Walcott first appeared in Philadelphia on October 15, 1892, and won a four-round decision against Jesse Moulton. In all, he fought in Philadelphia rings 20 times and never lost. He last boxed here on January 30, 1908, against Terry Martin in a six-round no-decision contest.

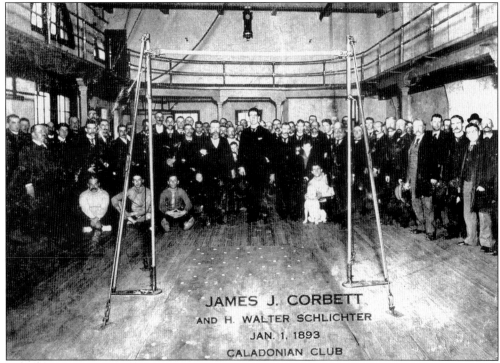

JAMES J. CORBETT
AND H. WALTER SCHLICHTER
JAN. 1, 1893
CALADONIAN CLUB

SLICK AND THE CHAMP. Jim Corbett (center) and Walter Schlichter (to Corbett's left) dropped by the Caladonian Athletic Club on January 1, 1893, and were included in this club picture. The club was a popular boxing site during the 1880s and 1890s. (Courtesy Antiquities of the Prize Ring and Tom Scharf.)

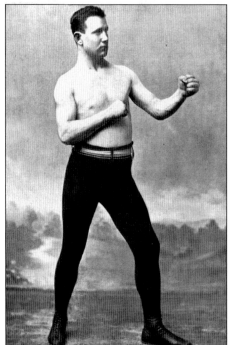

THE HEAVYWEIGHT CHAMPION OF PENNSYLVANIA. Jim Daly, shown here in an 1895 studio pose, fought most of his bouts in and around Philadelphia, even laying claim to the state's heavyweight championship, a title he invented for himself. On March 27, 1900, Daly squared off against erstwhile world heavyweight champion Bob Fitzsimmons, at the 1st Regiment Armory. Ruby Robert made short work of Daly, bludgeoning him unconscious in the very first round.

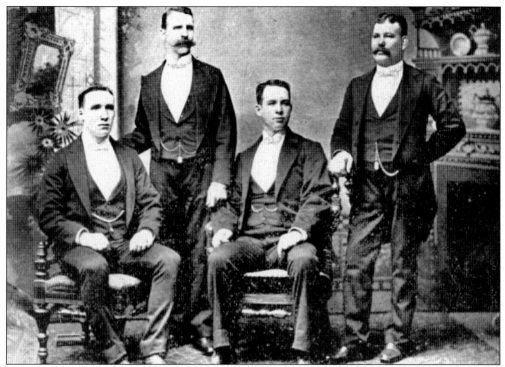

FOUR GENTLEMEN. Posing together are, from left to right, Jack Fogarty, Billy Edwards, Jack Ryan, and Arthur Chambers. Could these men use their fists? No doubt about it. They were all well-known fighters who appeared many times in Philadelphia.

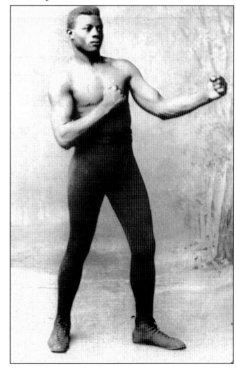

BLACK AND FIERCE. Fred Morris was a thrilling welterweight-middleweight fighter in Philadelphia through the 1890s. During his career, he defeated Jim Burge, Bill Dunn, Paddy Burke, Dick Baker, Charley Strong, Dick Moore, Frank Purcell, and "Starlight." (Courtesy Kevin Smith.)

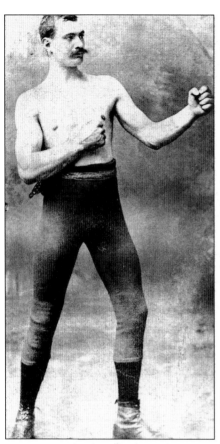

A DEVASTATING HITTER. Peter Maher was once middleweight champion of Ireland but grew into a heavyweight who mowed down larger and heavier men with ease. Maher was a devastating hitter who could strike quickly and for keeps. However, he was not a good boxer and was vulnerable to those who were. As a heavyweight, he was not a particularly good taker of punches. Maher appeared in Philadelphia many times.

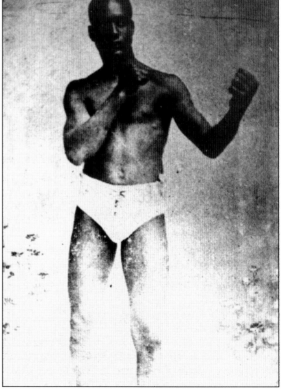

QUICK AND SLIPPERY. Joe Butler, born near Philadelphia, was a frequent and popular fighter in local rings throughout the 1890s. Butler was never more than a middleweight or light heavyweight but fought all the outstanding fighters of any weight class who would fight him.

STRONG IN WILL, STRONG IN SKILL.
Philadelphian Charlie McKeever, who
fought as a lightweight up through
middleweight from 1896 to 1906, was
a regular at the local clubs. McKeever
fought Billy Smith three times for the
welterweight championship but never
won. During his career, McKeever fought
10 champions. He was well built and
strong. His position was erect and natural,
and he was an excellent judge of distance
and superior at infighting. He was always
a well-behaved man who never drank.
(Courtesy Antiquities of the Prize Ring.)

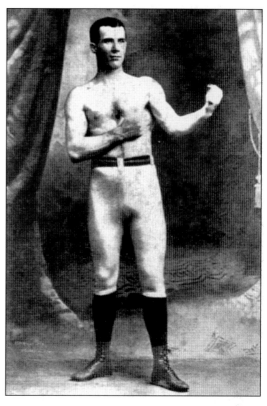

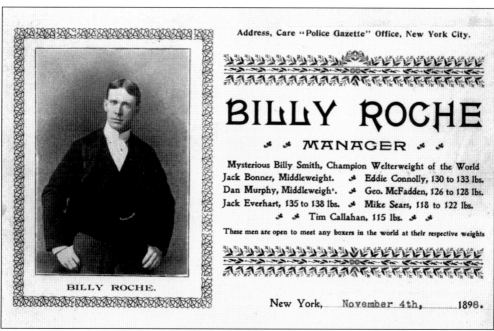

Address, Care "Police Gazette" Office, New York City.

BILLY ROCHE

❧ ❧ MANAGER ❧ ❧

Mysterious Billy Smith, Champion Welterweight of the World
Jack Bonner, Middleweight. ❧ Eddie Connolly, 130 to 133 lbs.
Dan Murphy, Middleweight. ❧ Geo. McFadden, 126 to 128 lbs.
Jack Everhart, 135 to 138 lbs. ❧ Mike Sears, 118 to 122 lbs.
❧ ❧ Tim Callahan, 115 lbs. ❧ ❧

These men are open to meet any boxers in the world at their respective weights

New York, November 4th, 1898.

BILLY ROCHE.

THE BUSINESS CARD OF BILLY ROCHE. Billy Roche was the manager of some outstanding
Philadelphia fighters during the 1890s. He was also a prominent referee for many bouts during
the 1890s and early years of the 1900s. (Courtesy Antiquities of the Prize Ring.)

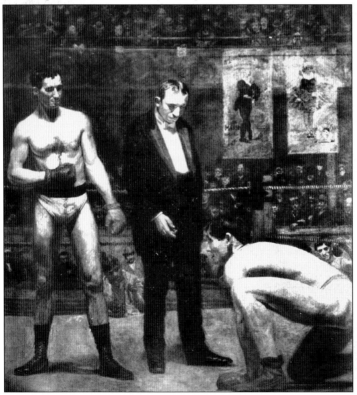

IT'S SO! WE ARE CLOTH WEAVERS AND CLOTHING MAKERS *Miller's Market St. below 10th*

...The Arena...

Programme for
Wednesday Ev'ng, December 22

Referee, H. WALTER SCHLICHTER

First Bout

"Young Smister" vs. Frank McGee
OF PHILADELPHIA OF PHILADELPHIA
SIX ROUNDS

Second Bout

Harry Burk vs. "Kid Howard"
OF SOUTHWARK OF CINCINNATI
SIX ROUNDS

Third Bout

Billy Smith vs. "Young Lenny"
THE 145 LB. CHAMPION OF PHILADELPHIA
SIX ROUNDS

Semi Wind Up

Martin Judge vs. "Young Smyrna"
OF ROXBOROUGH OF CHESTER
SIX ROUNDS

Wind Up

Jerome Quigley vs. Owen Ziegler
OF PHILADELPHIA OF PHILADELPHIA
SIX ROUNDS

THE NEXT SHOW
Will be held on next Monday Evening, December 27th. The
attractions will be announced to-night.

CLOTHING PRICES Fixed at a Small Profit Above Mill Cost *Miller's Market St. below 10th*

A FIGHT PROGRAM. Pictured is a program for the December 22, 1897 fight card at the Philadelphia Arena. (Courtesy Antiquities of the Prize Ring.)

TAKING THE COUNT. A play by this name was presented on April 18, 1898, at the Walnut Street Theatre. It was based on a bout between Charlie McKeever and Joe Mack at the Philadelphia Arena. This painting by Thomas Eakins shows McKeever standing over Mack, as referee Walter Schlichter carries out the count. (Courtesy Antiquities of the Prize Ring.)

BETWEEN ROUNDS. This painting by Thomas Eakins presents "Turkey Point" Billy Smith resting in his corner in his bout against Tim Callahan on April 22, 1898, at the Philadelphia Arena. His cornerman is Elwood McCloskey, and the man with the towel is Billy McCarney. Clarence Cranmer is the timekeeper at the table. (Courtesy Antiquities of the Prize Ring.)

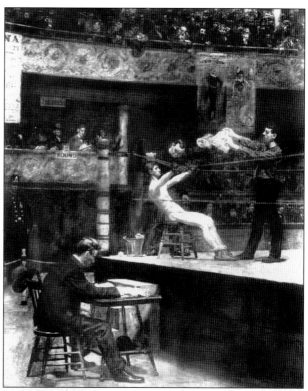

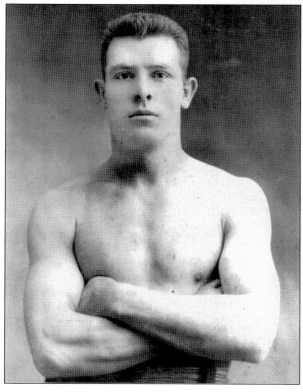

HE CHALLENGED TOMMY RYAN. Jack Bonner, outstanding middleweight of the 1890s, often fought in and around Philadelphia. On October 24, 1898, Bonner boxed Tommy Ryan in Brooklyn for the world middleweight championship. (Courtesy Antiquities of the Prize Ring.)

23

ARTICLES OF AGREEMENT.

These Articles of Agreement made and entered into this 28th day of November, 1898, between Peter Maher of Philadelphia and Meyer & Schlichter of Philadelphia, witnesseth that the said Peter Maher agrees to box one Ed Dunkhorst, Six (6) Rounds, Marquis of Queensbury Rules before The Arena Athletic Club of Philadelphia on Friday night, December 9th, 1898 in consideration of 40 per cent of the gross receipts of the house on the said night.

It is also agreed by the said Peter Maher to forward to Meyer & Schlichter the sum of One Hundred Dollars, ($100.) to insure his appearance in the ring on the above named date.

It is also agreed by Meyer & Schlichter to pay the face value of each genuine ticket taken in at the doors and they agree to take all reasonable precautions to prevent fraud in the tickets.

The Complimentary Tickets shall be limited to Two hundred, it is also agreed that members of The Arena Athletic Club who number Twenty Five (25) and have their membership tickets shall be admitted.

It is further agreed that should Peter Maher resort to any foul or unfair tactics the referee shall have full power to disqualify him and he shall forfeit part or all money coming to him under this agreement as the referee may decide.

For Peter Maher
Peter Lowry
Meyer & Schlichter
For Arena A.C.

THE ARTICLES OF AGREEMENT. This contract, which called for Peter Maher to fight Ed Dunkhorst, was signed on November 29, 1898, by Peter Lowery for Maher and by Meyer and Schlichter for the Philadelphia Arena. (Courtesy Antiquities of the Prize Ring.)

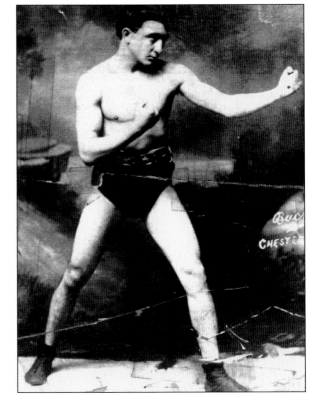

HE KNOCKED OUT GEORGE DIXON. Eddie Lenny (Setaro), a scrappy Philadelphia featherweight, waged his battles from 1896 to 1907 against such men as Terry McGovern, Freddie Welsh, and Jack Blackburn. Probably his most famous fight was a 25-round loss against George Dixon for the world featherweight championship on November 21, 1899, in New York. Later, in 1902, he knocked out Dixon in nine rounds at Baltimore. Lenny was the first Italian American to fight for a world title.

Two

1900–1909

Danny Dougherty was the first Philadelphia man to be hailed as world champion bantamweight, in 1900.

Fourteen fight clubs were operating in the immediate Philadelphia area at the turn of the century. The sport was banned temporarily in 1901 after two ring fatalities.

Boxing contests in the Quaker City still were limited to six rounds. This made for furious action. Stalling was not tolerated. Historians attribute the all-out fighting style used by many Philadelphia fighters to these old rules.

Philadelphia became the leading place for purse money. Many top boxers made appearances in Philadelphia rings. Some visitors had problems with the pace of the fights. Several world champions were beaten by locals, such as Tim Callahan, Yi Yi Erne, and Tommy O'Toole.

Jack Johnson, Bob Fitzsimmons, Sam Langford, Kid McCoy, Tommy Ryan, Joe Walcott, Joe Gans, George Dixon, Terry McGovern, and other legends frequently headlined shows in the city.

Jack O'Brien won the light heavyweight crown in 1905 and met almost every top fighter of the day, black and white. Harry Lewis won recognition as the welterweight champion in 1908. Many Philadelphia fistic followers claimed that Jack Blackburn was the best of them all.

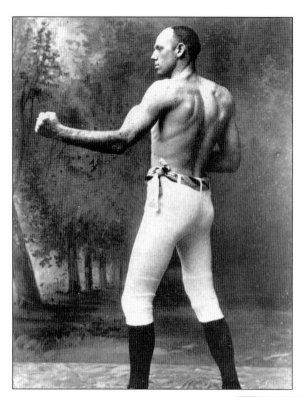

THE GREAT ONE RETURNS. Bob Fitzsimmons, former heavyweight champion, began a serious attempt to regain the title by knocking out Jim Daly on March 27, 1900, at the 1st Regiment Armory. Fitzsimmons appeared many times in Philadelphia during the early 1890s. On several occasions, he fought two or three men on the same date.

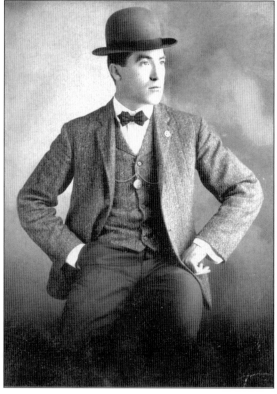

THE FIRST PHILADELPHIA WORLD CHAMPION. Danny Dougherty was an outstanding bantamweight who fought from 1895 to 1914. During his career, he fought such men as Casper Leon, Clarence Forbes, Tommy Feltz, Harry Forbes, George Dixon, and Owen Moran. Dougherty won the world bantamweight championship on May 26, 1900, in Brooklyn against Tommy Feltz in 20 rounds. (Courtesy Antiquities of the Prize Ring.)

ATHLETE, REFEREE, AND PROMOTER. H. Walter Schlichter was a prominent figure in Philadelphia athletics during the 1890s and early 1900s. Later, he became sports editor for the *Philadelphia Item*. (Courtesy Antiquities of the Prize Ring.)

AMONG THE BEST. Tim Callahan, active from 1896 to 1909, was a top contender for the bantamweight and featherweight titles at the turn of the century. During his career, he fought Terry McGovern three times, George Dixon three times, Eddie Lenny six, Austin Rice five, Sammy Smith five, Harry Forbes three, and Harry Lewis and Harry Harris once each.

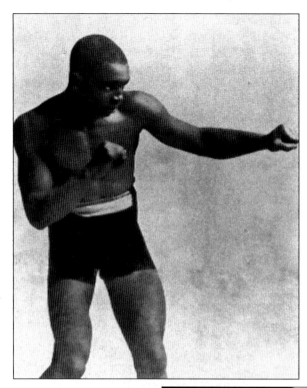

HE FOUGHT 'EM ALL. Dave Holly was a regular in Quaker City boxing events from 1900 to 1910. A good, solid boxer, Holly went up against some top-flight men during his career, such as Sam Langford, Joe Gans, Joe Walcott, Dixie Kid, Jack Blackburn, and Jeff Clark. (Courtesy Antiquities of the Prize Ring.)

HE BEAT SOME OF THE BEST. "Young" Peter Jackson from Baltimore got off to a bad start in Philadelphia against Joe Walcott, who outclassed him on January 13, 1902. Jackson later redeemed himself in Philadelphia rings with outstanding fights against Walcott and other good men, such as Jack Bonner, Tommy West, Charlie McKeever, Jack O'Brien, Joe Butler, and Joe Jeannette. (Courtesy Bob Carson.)

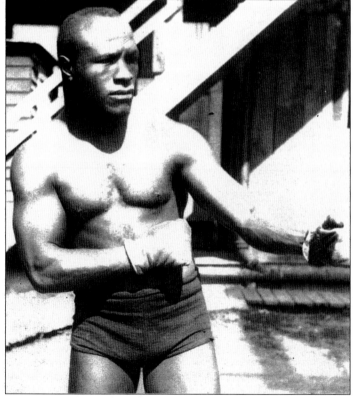

A TOP HEAVYWEIGHT. Gus Ruhlin of Akron (standing) poses with his manager, Billy Madden. Ruhlin was a good, skillful fighter but was erratic. When he was good, he was very good, but when he was bad, he was awful. Ruhlin fought in Philadelphia several times between 1898 and 1904. Perhaps his greatest Philadelphia victory came against Peter Maher on March 21, 1902, when he knocked out the fierce hitter in two rounds. His only defeats in the Quaker City came in 1904, when he lost to Jim Jeffords and Marvin Hart.

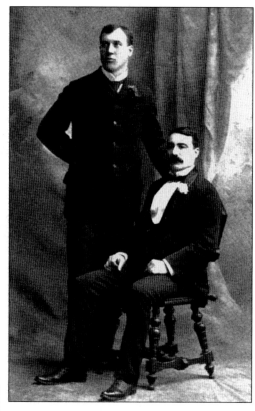

THE OLD MASTER. Joe Gans was a great one. He boxed from 1891 to 1909 and was lightweight champion of the world during his career. Many historians rate him as the best lightweight ever. Gans boxed in Philadelphia 21 times and was beaten only once. (Courtesy Antiquities of the Prize Ring.)

FITZ KILLED HIM. Heavyweight Con Coughlin boxed Bob Fitzsimmons on September 30, 1903, at the Washington Sporting Club. He was knocked out by Fitzsimmons and died the next day. (Courtesy Antiquities of the Prize Ring.)

WILLIAMS VERSUS SULLIVAN. Hard-hitting Philadelphia middleweight Jack Williams lands a right-hand punch against veteran Jack "Twin" Sullivan on October 29, 1903, at the Broadway Athletic Club, at 15th and Washington Streets. The two battlers fought to a six-round draw.

O'BRIEN VERSUS McCOY. Robert Edgren put his views about the May 14, 1904 bout at the 2nd Regiment Armory on paper. "Jumping Jack" O'Brien had Kid McCoy guessing in spite of his sneer. McCoy used a backhander to floor O'Brien in the six-round no-decision contest.

A GREAT FIGHTER. Jack Johnson fought often in Philadelphia between 1903 and 1905. Johnson fought more bouts in Philadelphia than any other city except his hometown. In fact, he probably remembered the circumstances surrounding his initial showing there until the moment he died. Leaving the ring after knocking out Joe Butler at the Washington Sports Club in 1903, Johnson was pounced on by local boxer Harry Burk and hit over the head from behind with a bottle, leaving him with a gaping scalp wound that bled profusely. This was a follow-up to a dressing room altercation before his bout with Butler when he refused to lend Burk a towel.

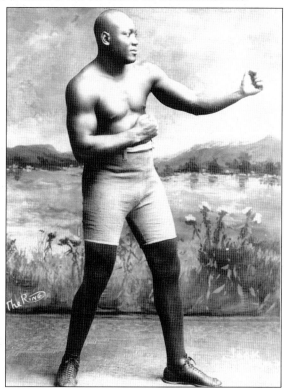

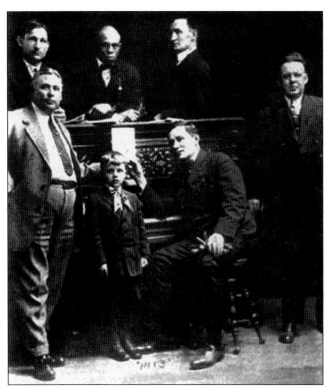

JACK BLACKBURN WITH FRIENDS. Lightweight Jack Blackburn (back row, second from the left) was a main attraction in Philadelphia from 1903 to 1918. In 1909, he was arrested for the murder of Alonzo Polk and the attempted murder of Polk's wife, Mattie. He was convicted and served time in prison from 1909 to 1913. James "Baron" Dougherty (seated) was fundamental in freeing Blackburn. Beside Dougherty is his son Howard, and next to Howard is "Diamond Lew" Bailey, longtime promoter at the Broadway Athletic Club. Behind the piano facing left is Jack McGuigan, promoter at the National Athletic Club. (Courtesy Antiquities of the Prize Ring and Tom Scharf.)

"PHILADELPHIA" JACK. Jack O'Brien was one of the best middleweight and light heavyweight fighters in boxing history. He fought out of Philadelphia from 1896 to 1912 and engaged in more than 175 bouts. He won the light heavyweight championship but never defended it.

As Tough as Nails, like a Bulldog.
Where but in Philadelphia could a Joe Grim
have been a hero? Grim (Saverio Giannone)
was a 150-pound iron man who survived
frightful beatings at the hands of the game's
most powerful punchers. In July 1905, more
than 10,000 Italian fans waited anxiously
outside the National Athletic Club, at 11th
and Catherine Streets, for word of the outcome
of his bout with Jack Johnson and celebrated
far into the night when word was flashed that
Grim lasted the limit because Johnson failed to
knock him out officially. (Courtesy Antiquities
of the Prize Ring.)

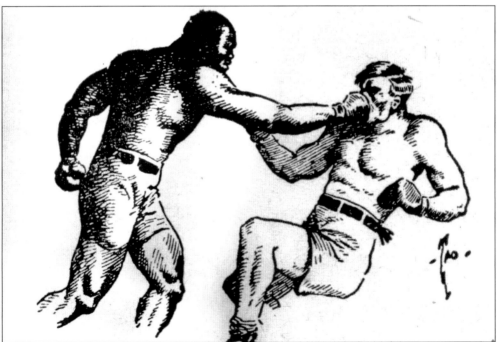

Johnson Couldn't Put Grim Away. The fact that Grim lay unconscious in the ring center
after suffering 16 knockdowns did not deter the spectators' exhilaration. The referee's count had
only reached six when the final bell was rung over the prostrate Grim, thus saving thousands of
dollars in wagers for his countrymen. (Courtesy Antiquities of the Prize Ring.)

ANOTHER TOUGH MAN. Fred Cooley fought out of Philadelphia as a middleweight and light heavyweight from 1902 until 1909. He was quite active in local rings in 1903 and 1904 and then went to the Midwest. His greatest victories came on October 27, 1904, when he knocked out Peter Maher in one round at Philadelphia and on November 12, 1906, at Hibbing when he defeated Jim Barry in six rounds. (Courtesy Antiquities of the Prize Ring.)

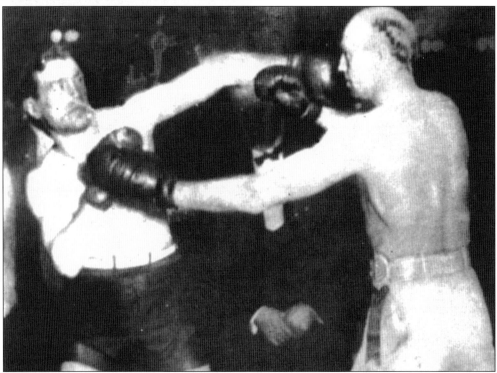

TWO OF THE BEST. Jack O'Brien (left) poses with Bob Fitzsimmons before their December 20, 1905 bout at San Francisco for the light heavyweight championship. O'Brien knocked out Fitzsimmons in 13 rounds.

HE FOUGHT MANY FIGHTS. Kid Beebe (Frank Boro) from South Philadelphia was active in local rings from 1900 to 1915 and claimed to have more than 600 bouts during his career. Most of his bouts were held by 1910, and he usually fought in the Quaker City. (Courtesy Antiquities of the Prize Ring.)

A POPULAR GUY. Lightweight John "Unk" Russell, active from 1904 until 1912, was one of Philadelphia's most popular warriors. He was from the Gray's Ferry section. Among the men he battled were Jimmy Briggs, Harry Lewis, Dal Hawkins, Young Erne, Willie Fitzgerald, Young Otto, and Johnny Willetts.

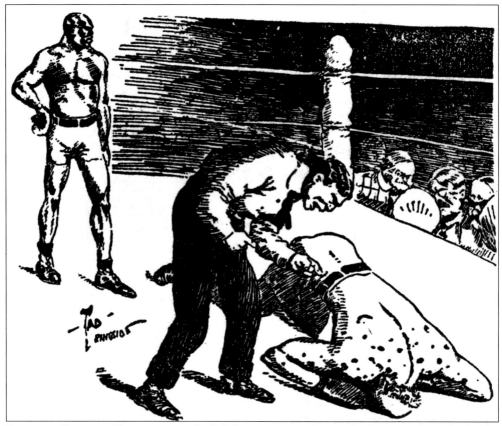

JOHNSON DEFEATS FITZSIMMONS. Jack Johnson was at his peak in 1907. On July 17, he knocked out old Bob Fitzsimmons at the Washington Sporting Club in two rounds, as portrayed in this drawing by TAD (Tad Dorgan). (Courtesy Antiquities of the Prize Ring.)

ONE OF THE BEST. Harry Lewis (Besterman) was born in New York but came to Philadelphia as a child and lived here until his death in 1956. The redhead was a popular draw and won the world welterweight championship in 1908. During his career, he had 171 bouts and was only knocked out twice. Archrival Willie Lewis once said, "What Harry doesn't know about boxing isn't worth learning."

THE "FIGHTING GHOST." Jeff Clark was a native of Merchantville, New Jersey, and was an uncle of "Jersey Joe" Walcott. He moved to Joplin, Missouri, later in his life. Clark fought many times in Philadelphia, mostly during the period from 1908 to 1910. He was quick and slippery and carried a good punch. In 23 known bouts here, his record was 18 wins, 3 losses, 1 draw, and 1 no contest. He defeated such men as Sam Langford, Peter Maher, "Battling Jim" Johnson, Jack Williams, and Dave Holly. (Courtesy Bob Carson.)

ONE OF THE MOORES. Reddy Moore was a capable bantamweight who fought in the first decade of the 20th century. During his career, Moore scored victories over such men as Benny Kaufmann, Mike Malone, Harry Stone, and Jack Britton (two times). He was a brother of Pal, Willie, Frankie, and Al Moore. (Courtesy Joe Cassidy.)

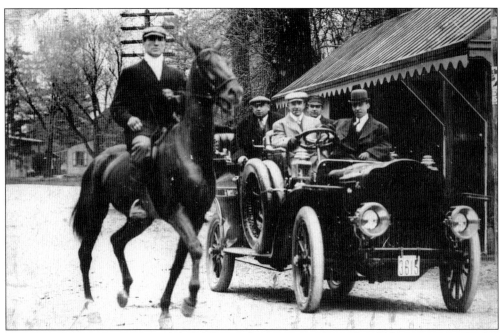

A NICE DAY FOR A RIDE. "Philadelphia Jack" O'Brien takes a break from training for his 1909 fight with Jack Johnson and goes for a ride on horseback. (Courtesy Antiquities of the Prize Ring.)

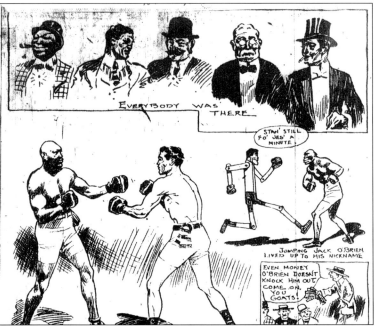

JOHNSON TOO BIG FOR JACK O'BRIEN

Had Best of Philadelphia Boxer in Six Rounds, But Failed to Stop Him.

LOCAL MAN VERY GAME

Took Fight to His Larger Opponent and Gained Credit for His Showing.

Weighing 43 pounds less than the giant negro, Champion Jack Johnson, Jack O'Brien last evening gamely carried the fight to the big colored man for the greater part of six rounds at the National A. C., and was still strong on his feet at the end. But in doing this O'Brien got some very hard bumps and was pretty badly hurt at times, and there is no doubt that the negro had the better of the contest. But O'Brien deserves full credit for the way he went after his larger opponent, who, while holding the proud title of champion of the world, seemed for the greater part of the time disposed to loaf along and make the contest as easy as possible. But on a few occasions Johnson cut loose with great vigor and then it was that O'Brien was punished severely. The white man was down several times, though only once on a fair knock-down. Once O'Brien was carried through the ropes by one of Johnson's fierce rushes and had it not been for

JOHNSON TOO BIG FOR O'BRIEN. Jack O'Brien had fantastic boxing skills, but so did Jack Johnson, and Johnson was bigger. Outweighed by 43 pounds, O'Brien pressed their fight at the National Athletic Club on May 19, 1909, as did most of Johnson's opponents. He had little success, as did the others. Johnson boxed in an easy manner and fired explosive punches from time to time. O'Brien was game and lasted the six rounds.

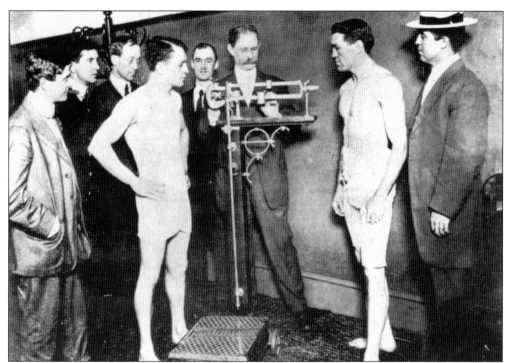

GREAT FIGHTERS BUT NO GREAT FIGHT. Stanley Ketchel and Jack O'Brien (right) are shown weighing in before their June 9, 1909 bout at the National Athletic Club. Ketchel stopped O'Brien in round three.

A CAPABLE WELTERWEIGHT. Tommy Howell (Antonio Lauletta) was a top welterweight who fought regularly in Philadelphia from 1909 to 1914. Some of the men he defeated during his career were Henry Hauber, Willie Moody, Ray Bronson, Johnny Krause, Dick Nelson, and Young Nitchie. (Courtesy Antiquities of the Prize Ring and Tom Scharf.)

HE FOUGHT MANY GOOD ONES.
Lightweight Billy Willis fought from 1902 to 1912 almost exclusively in Philadelphia. During his career, Willis fought such men as Terry McGovern, Tim Callahan, Jimmy Briggs, Harry Lenny, Austin Rice, Young Erne, Johnny Willetts, Tommy Howell, and Jim "Wildcat" Ferns. (Courtesy Antiquities of the Prize Ring.)

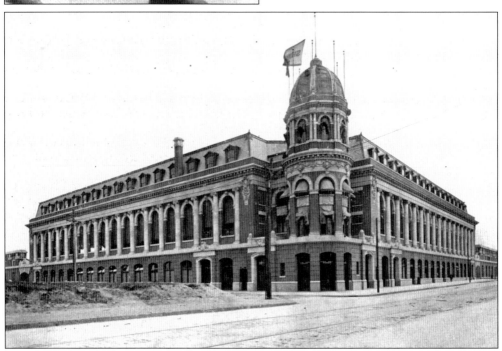

ELOQUENT SHIBE PARK, 1909. This beautiful structure provided thrills and exciting times for followers of sports for many years. It was the scene of a number of important boxing contests during its lifetime. (Courtesy the Print and Picture Collection, Free Library of Philadelphia.)

Three

1910–1919

Harry Lewis continued to strengthen his claim as welterweight champion by defeating all opponents in Europe. He defended his title several times.

In 1912, the Olympia Athletic Club opened and competed with the National Athletic Club as a premier fight arena. Also in 1912, Herman Taylor, a protégé of Jack McGuigan (the boss at the National), purchased the Broadway Athletic Club from Diamond Lew Bailey and went on to promote boxing longer than any man in history.

In 1914, open-air boxing was inaugurated by Johnny Burns at the Cambria. The "outdoor season"-lasted for more than 40 years.

Battling Levinsky won the light heavyweight title from Jack Dillon in 1916 and became one of the most active fighters in history.

In 1917, Burns purchased a movie theater at Kensington and Somerset. On February 2, in his initial show, Joe Borrell boxed Jeff Smith. The Cambria became known as the "bucket of blood" and was one of the most famous in the country.

The same year, Herman Taylor formed a partnership with Bobby Gunnis and ran outdoor shows at Shibe Park. These all-star cards became nationally famous and pitted the world's best boxers against local stars.

On July 25, 1917, Benny Leonard knocked out Johnny Kilbane in the Battle of Champions.

Philadelphia's amateur program and newsboy tournaments produced many outstanding Jewish fighters, including Eddie O'Keefe, Louisiana, Frankie Bradley,-Gussy Lewis (brother of Harry), Lew Tendler,-and Battling Levinsky. The Jewish fighters were replacing the Irish as the dominant group in local boxing.

In 1918, local fans got their first glimpse of a vicious heavyweight-fighting machine when Jack Dempsey came to town.

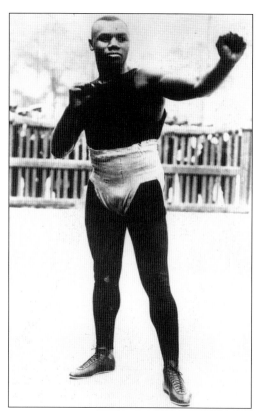

THE TOUGHEST MAN WHAT AM. Sam Langford, who spoke with a lisp, fought in Philadelphia on many occasions. Langford was one of the best fighters during the first two decades of the 20th century. He began fighting as a lightweight and moved up through the weight classes as he got larger. His best weight was that of a light heavyweight. His most memorable fights in Philadelphia occurred on April 27, 1910, against Stanley Ketchel and on May 11, 1917, against Harry Wills.

A BIG MAN WITH A BIG PUNCH. "Battling Jim" Johnson was another popular heavyweight who appeared in Philadelphia frequently in 1910. He was not a good boxer but was huge and strong and always stood a puncher's chance. During his career, he fought Joe Jeannette 11 times, Sam Langford 10 times, and Sam McVey 7 times. Battling Jim fought Jack Johnson for the world heavyweight championship on December 19, 1913. (Courtesy Antiquities of the Prize Ring.)

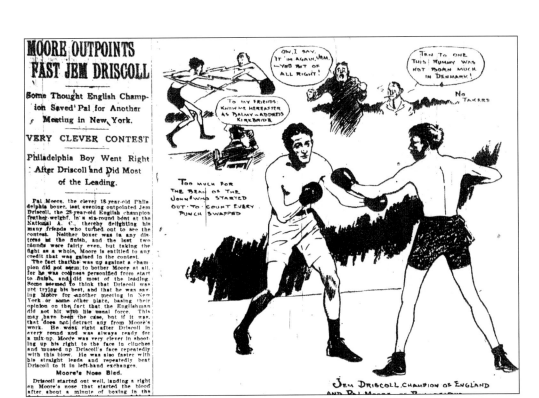

MOORE OUTPOINTS FAST JEM DRISCOLL

Some Thought English Champion Saved Pal for Another Meeting in New York.

VERY CLEVER CONTEST

Philadelphia Boy Went Right After Driscoll and Did Most of the Leading.

Pal Moore, the clever 18-year-old Philadelphia boxer, last evening outpointed Jem Driscoll, the 25-year-old English champion feather-weight, in a six-round bout at the National A. C., thereby delighting his many friends who turned out to see the contest. Neither boxer was in any distress at the finish, and the last two rounds were fairly even, but taking the fight as a whole, Moore is entitled to any credit that was gained in the contest.

The fact that he was up against a champion did not seem to bother Moore at all, for he was coolness personified from start to finish, and did most of the leading. Some seemed to think that Driscoll was not trying his best, and that he was saving Moore for another meeting in New York or some other place, basing their opinion on the fact that the Englishman did not hit with his usual force. This may have been the case, but if it was, that does not detract any from Moore's work. He went right after Driscoll in every round and was always ready for a mix-up. Moore was very clever in shooting up his right to the face in clinches and mussed up Driscoll's face repeatedly with this blow. He was also faster with his straight leads and repeatedly beat Driscoll to it in left-hand exchanges.

Moore's Nose Bled.

Driscoll started out well, landing a right on Moore's nose that started the blood after about a minute of boxing in the

A CLEVER CONTEST. Eighteen-year-old Pal Moore pulled a shocker when he went right after the great Welsh boxer Jem Driscoll on May 25, 1910, at the National Athletic Club. Moore held his own, and many observers thought he won.

OPEN TO BLACK FIGHTERS. Through the years, Philadelphia was probably the most "open" large city in the country to black fighters. During Jack Johnson's reign as heavyweight champion, when blacks became nearly extinct in the sport, three black Philadelphians—Young Pierce, Preston Brown, and Tommy Coleman (pictured)—were among the most popular attractions in the city.

43

A SUPER FIGHTER. Joe Jeannette, born in North Bergen, fought many times in Philadelphia, especially early in his career. Jeannette was one of the outstanding heavyweight fighters of the second decade of the 20th century. During his career, he fought Jack Johnson nine times, Sam Langford fifteen times, and Sam McVey five times.

THE GREAT ERNE. Young Erne was a wonderful fighter and very popular in Philadelphia between 1900 and 1917. During his career, he fought against an unbelievable array of talent, such as Packey McFarland, Freddie Welsh, Jack Britton, Mike Gibbons, Al McCoy, Leo Houck, Abe Attell, Harry Lewis, Johnny Summers, Leach Cross, and many others. Shown here is one writer's opinion that Erne bested Gibbons on December 16, 1911, at the National Athletic Club.

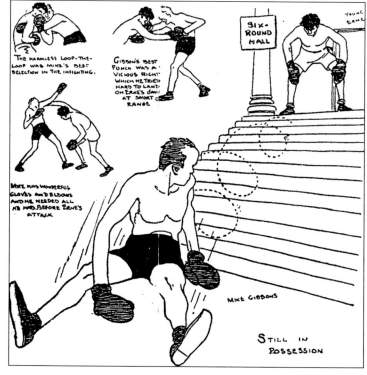

THE ORIGINAL. "Philadelphia" Pal Moore was the original Pal Moore. He is sometimes confused with "Memphis" Pal Moore. He boxed as a lightweight and peaked early in the second decade of the 20th century. He was a brother of Reddy, Willie, Frankie, and Al Moore. (Courtesy Joe Cassidy.)

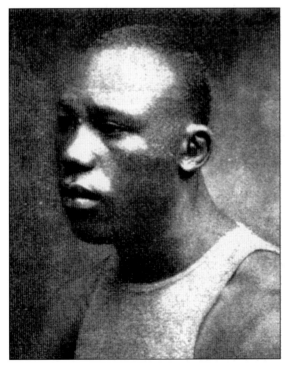

A TALENTED INVADER. Eddie Palmer, a native of New Orleans, arrived in Philadelphia in August 1911. In two years of action in Philadelphia clubs, he held his own with such stars as Young Erne, Tommy Coleman, Joe Borrell, Jim Hosic, Kid Wagner, and George Ashe. His most impressive bouts were his 1912 newspaper win over Jeff Smith and his two draws with future light heavyweight champion Battling Levinsky. Palmer knocked each man down. (Courtesy Kevin Smith.)

45

THE GUNBOAT. Philadelphia-born Edward "Gunboat" Smith moved quickly and struck stinging blows. He weighed little more than a light heavyweight during his career but competed against the best of the larger men. He claimed the white heavyweight championship of the world on January 1, 1914, when he stopped Arthur Pelkey in 15 rounds at San Francisco. The durable Smith is famous for his slashing battles against Jack Dempsey. It took nine knockdowns for Jack to stop him on December 30, 1918, in Buffalo.

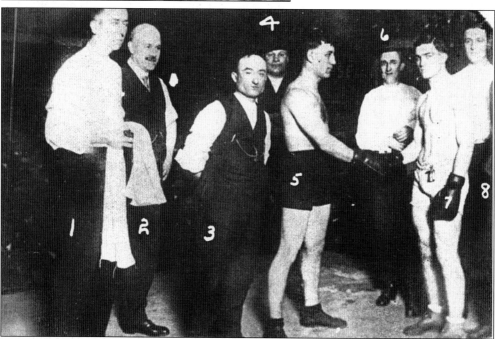

TITLE CLAIMANTS. Joe Borrell (left), a middleweight from Kensington, and Leo Houck, a welterweight from Lancaster, shake hands before their match at the National Athletic Club, at 11th and Catherine Streets, on January 17, 1914. Houck floored Borrell in round one and was the winner of the six-round contest in the opinion of the reporters.

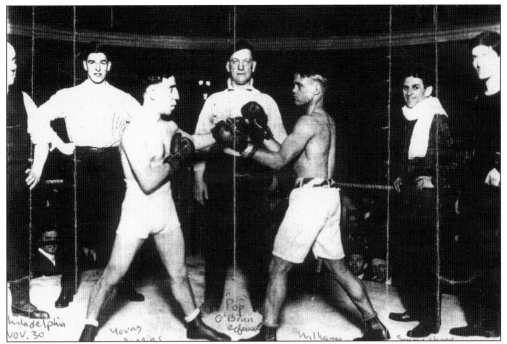

WILLIAMS AND DIGGINS. Kid Williams (right) and Freddie "Young" Diggins pose before their encounter at the Olympia Athletic Club on November 30, 1914. Williams, who fought often in Philadelphia, ended this one in the third round. Sammy Harris is standing behind Williams with the towel around his neck.

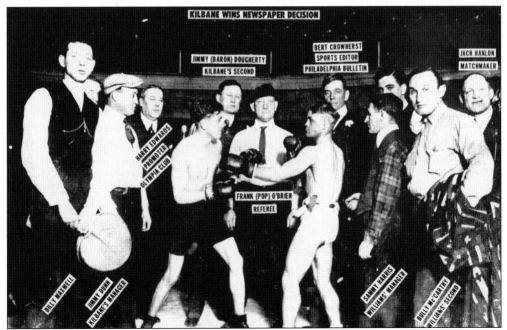

TWO GREAT ONES. Featherweight Johnny Kilbane (left) and bantamweight Kid Williams square off before their fight on March 17, 1915, at the Olympia Athletic Club. Kilbane was a newspaper winner in six rounds.

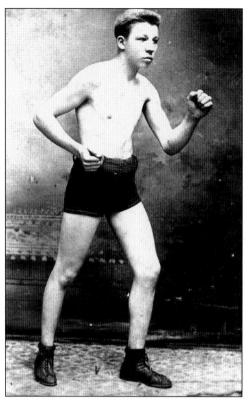

ANOTHER MOORE. Willie Moore, fourth of the fighting Moore brothers (Frankie, Reddy, and Pal were older; Al was younger), was a hard-punching southpaw crowd-pleaser who claimed the welterweight title after knocking out "Young Jack" O'Brien in April 1915. He also beat Tommy Howell and knocked out, among others, Willie Moody and Jack Farrell. He lost all claims to the title when he was beaten by Steve Latzo at Tamaqua in 15 rounds in a bout listed for the world welterweight championship. (Courtesy Joe Cassidy.)

EDDIE O'KEEFE. Bantamweight-featherweight Eddie O'Keefe had a long career lasting from 1908 until 1923. He fought some of the best and garnered some impressive wins along the way. O'Keefe owned victories over Johnny Dundee, Patsy Kline, Young Driscoll, Joe Coster, Johnny Solzberg, Jackie "Kid" Wolf, and Kid Williams. (Courtesy Antiquities of the Prize Ring.)

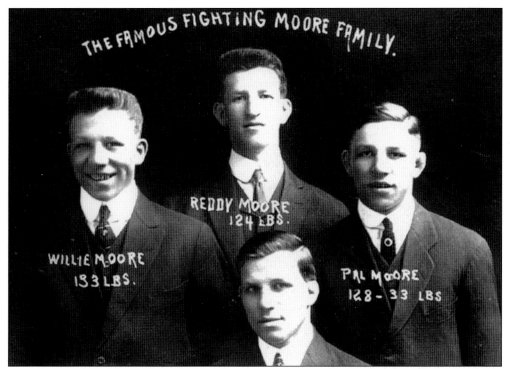

THE MOORES, A FAMILY OF FIGHTERS. Five brothers of the Moore family of South Philadelphia boxed on the same program on May 21, 1915, at the National Athletic Club in the Quaker City. Willie, Reddy, Pal, and Frankie were joined by younger brother, Al, on this memorable evening. (Courtesy Joe Cassidy.)

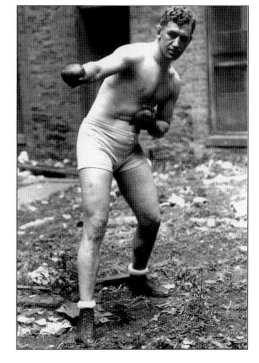

PUT 'EM UP. Battling Levinsky, whose real name was Barney Lebrowitz, was from Philadelphia and was an all-time great light heavyweight who engaged in more than 280 bouts during his career from 1909 to 1930. Some boxing historians claim he began in 1906. On October 24, 1916, Levinsky claimed the light heavyweight title with a win over Jack Dillon in Boston in 12 rounds.

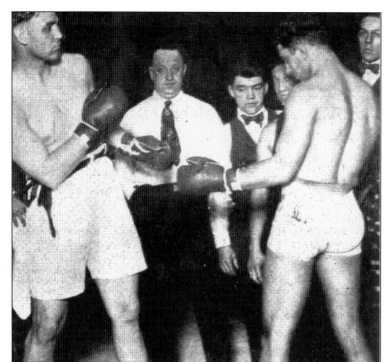

LEVINSKY LOSES TO MORRIS. Battling Levinsky (right) squares off against big Carl Morris before their bout on November 16, 1916, in Kansas City. Morris won in 15 rounds.

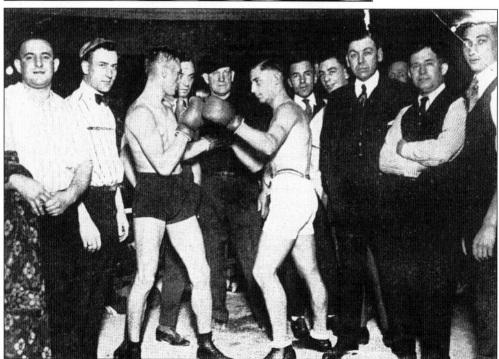

A SECOND GO-AROUND. Benny Leonard (right) and Johnny Tillman put up their dukes prior to their six-round bout at the Olympia Athletic Club on March 12, 1917. It was their second six-rounder in Philadelphia. On September 25, 1916, Leonard won a debatable victory over Tillman. A capacity crowd was on hand and witnessed as Leonard captured this one too.

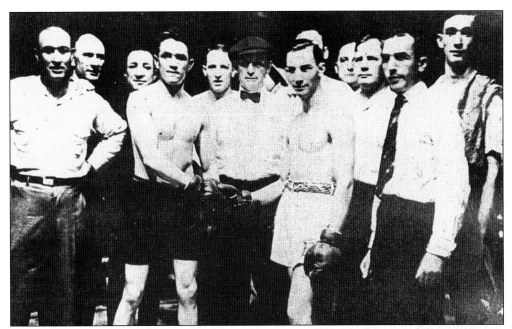

THE BATTLE OF CHAMPIONS. Lightweight champion Benny Leonard (right) shakes hands with featherweight champion Johnny Kilbane before their July 25, 1917 bout at Shibe Park. Both men were big favorites in Philadelphia, where they boxed frequently. Leonard stopped Kilbane in round three before 17,000 fans.

READY, WILLING, AND ABLE. Harry Greb, the man numerous boxing people have called the greatest middleweight of all time, fought in Philadelphia many times. Born in Pittsburgh, Greb came to fight. His goal was to win, and he did not care much how he did it. Quick, bouncy, durable, and rough, Greb was a nonstop puncher who used every tactic in the book against his opponent. (Courtesy Antiquities of the Prize Ring.)

AS SLICK AS A WHISTLE. Billy Miske, a native of St. Paul, first set foot in a Philadelphia ring on May 16, 1914, against George Ashe. Miske fought in Philadelphia a number of times afterward. One of his greatest performances was against Jack Dempsey on November 28, 1918.

THIS MAN CAME TO FIGHT. In November 1918, local fans got their first glimpse of the most vicious heavyweight fighting machine they had ever witnessed when Jack Dempsey flattened Battling Levinsky and Dan "Porky" Flynn at the Olympia Athletic Club and defeated Billy Miske at the National Athletic Club. Dempsey actually stayed in the area for many months, living at "Baron" Dougherty's Colonial Hotel in nearby Leiperville, waiting tables and working a brief stint at the Sun shipyard to avoid the draft during World War I.

Four

1920–1929

In April 1920, boxing matches were permitted to be eight no-decision rounds and a boxing commission was proposed to regulate the sport. After debate, a state athletic commission was established and bouts were allowed to be 10 rounds with official decisions rendered on December 1, 1923.

Lew Tendler fought Benny Leonard twice for the lightweight title without success. Tendler also fought Mickey Walker for the welterweight crown in 1924 in Philadelphia's first title contest. Walker's youth and speed were too much for Tendler, who lost but remained a contender until he retired in 1928.

In 1921, the Ice Palace, later renamed the Philadelphia Arena, became the city's top boxing venue.

Featherweights Danny Kramer, Eddie "Kid" Wagner, and Harry "Kid" Brown, along with Italian bantamweights Patsy Wallace (Appellucci), Battling Murray (DiRenza), and Bobby Wolgast (Giordano), almost made it to the throne room. Wolgast performed a wonderful feat when he whipped reigning champions Frankie Genaro, Joe Lynch, and Pancho Villa during the 1923 outdoor season.

In 1925, Jimmy Toppi opened the new Broadway Arena, which became famous for the Italian and black boxers it produced. Those boxers eventually replaced the Jewish fighters as Philadelphia's dominate force. Toppi remained an important figure for 40 years.

In 1926, Gene Tunney defeated Jack Dempsey in Philadelphia during a rainstorm with more than 120,000 fans present. Benny Bass won the world featherweight championship in 1927 and, less than a month later, Tommy Loughran won the world light heavyweight crown and relinquished it after five defenses.

Bass dropped his title in 1928 to Tony Canzoneri. He broke his collarbone in the third round of this bout. Then, Harry Blitman beat Canzoneri in a nontitle bout but later lost to Benny Bass. Bass went on to win the junior lightweight title in 1929.

George Godfrey, the "uncrowned heavyweight champion," spread terror throughout the division. Even Harry Wills refused to mix with "Big Gawge."

THE END OF THE LINE. Battling Levinsky (right) met Georges Carpentier at Jersey City on October 12, 1920, and lost the light heavyweight championship in four rounds.

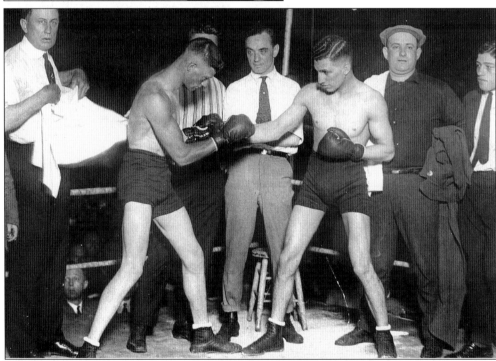

JUST BEFORE THE ACTION BEGINS. Lew Tendler and Bobby Barrett square off for their June 6, 1922 bout at the Baker Bowl. Tendler won by knockout in round six. From left to right are James "Baron" Dougherty, Bobby Barrett, an unidentified person (behind Barrett), referee Herman Taylor, Lew Tendler, Scoodles Reinfeld, and Joe Tiplitz. (Courtesy Rich Pagano.)

VILLA, WILDE, AND WOLGAST.
South Philadelphian Bobby
Wolgast pulled a remarkable feat
when he defeated three reigning
champions—Pancho Villa, Joe
Lynch, and Frankie Genaro—in
less than two months during
1923. All contests were no-
decision bouts in which Wolgast
received the newspaper decision.
Wolgast (right) is shown here
with Pancho Villa (left) and
Jimmy Wilde (center) before his
bout with Villa on May 11, 1923,
at the Baker Bowl (also known as
the Phillies Ballpark).

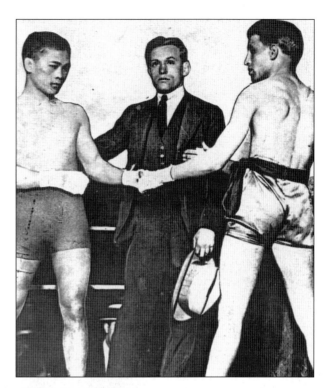

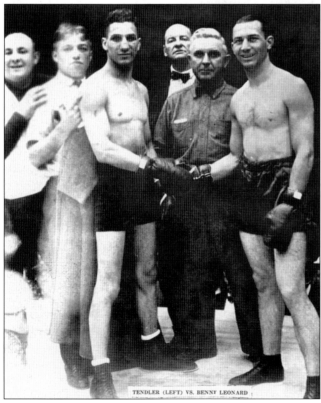

TENDLER (LEFT) VS. BENNY LEONARD

THE BEST. Benny Leonard
and Lew Tendler (left) shake
hands before their lightweight
championship bout on July 24,
1923, in New York. Leonard
won in 15 rounds.

55

NATE GOLDMAN. This Jewish welterweight from Kensington began boxing in California. His career lasted from 1923 to 1930, and he had victories over such men as Hymie Gold, Phil Salvadore, Pinky Mitchell, Bobby Barrett, Jimmy Sacco, Joe Tiplitz, Sid Barbarian, and Pete Hartley. His greatest win came on January 1, 1924, when he defeated Lew Tendler in 10 rounds at the Philadelphia Arena.

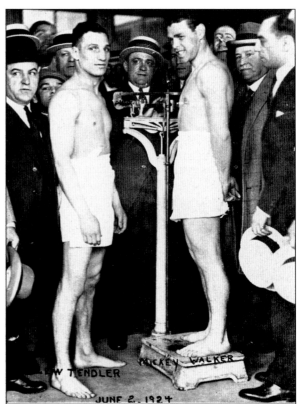

HE HAS THE ANSWER. Future middleweight champion Mickey Walker (right) smiles knowingly at the weigh-in for his bout with southpaw technician Lew Tendler at the Baker Bowl. Walker won in 10 rounds on June 2, 1924.

THE LITTLE FIRECRACKER.
Benny Bass was world champion
as a featherweight and junior
lightweight and fought more than
225 bouts during his career, which
lasted from 1921 to 1940. Jack
Dempsey once called Bass the
greatest pound-for-pound fighter he
ever saw. (Courtesy Rich Pagano.)

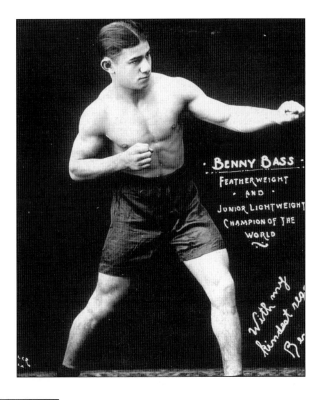

A HARD HITTER. Danny Kramer was
originally out of Boston. He boxed there
and in California early in his career. After
signing with Max "Boo Boo" Hoff and
moving to Philadelphia, he became a top
featherweight contender with his exciting
all-action, hard-punching southpaw style.
After Johnny Dundee gave up the title in
1924, an elimination tournament was set
up, with many of the best feathers in the
country involved. When the dust cleared,
Kramer and Louis "Kid" Kaplan met for the
undisputed featherweight crown on January
2, 1925, at Madison Square Garden. Kaplan
won on a ninth-round stoppage "in one of
the most savage brawls ever staged at the
Garden," according to famed writer and
cartoonist Ted Carroll.

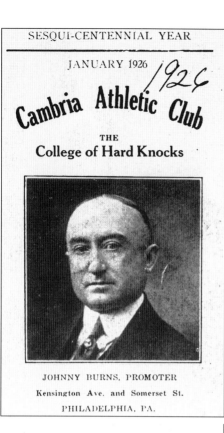

SESQUI-CENTENNIAL YEAR

JANUARY 1926 *1924*

Cambria Athletic Club

THE
College of Hard Knocks

JOHNNY BURNS, PROMOTER

Kensington Ave. and Somerset St.

PHILADELPHIA, PA.

THE CAMBRIA ATHLETIC CLUB. Dated January 1926, this is an advertisement for the Cambria Athletic Club under the direction of Johnny Burns.

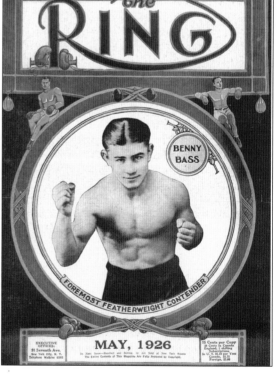

COVER BOY. Benny Bass was very active early in 1926 and owned victories over Joe Nelson, Leo "Kid" Roy, Al Corbett, Wilbur Cohen, and Ralph Ripman by mid-April. His performances earned him a spot on the cover of the *Ring* for May 1926. (Courtesy Antiquities of the Prize Ring.)

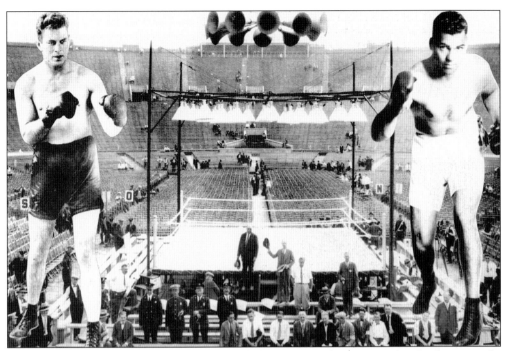

THE SCENE. Gene Tunney (left) challenged champion Jack Dempsey for the heavyweight championship on September 23, 1926. A record crowd of 120,757 attended the bout at Sesquicentennial Stadium.

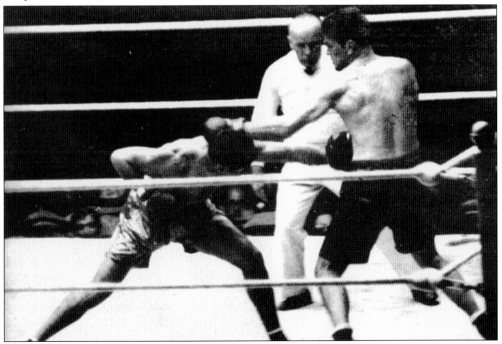

HOT AND HEAVY ACTION. Champion Jack Dempsey (left) attempts to get in a left to the body against the slippery challenger. Tunney held him off and decisioned Dempsey in 10 rounds to capture the title.

A RACKETEER DELUXE. Max "Boo Boo" Hoff was a racketeer who managed a stable of boxers during the 1920s and had his hands in almost everybody's pockets as fight promoter, manager, bootlegger, and rackets boss. Gene Tunney once testified that he witnessed the signing of a contract by his manager, Billy Gibson, giving Hoff 20 percent of the future champ's purses. Hoff, Gene had learned, had applied his enormous influence to save his match with Dempsey and bring it to Philadelphia when it was banned by New York officials, who held out that Harry Wills deserved the shot. Hoff was also said to have "guaranteed" a Tunney victory even in the case of a knockout by having a doctor ready to jump in the ring and claim that Tunney had been fouled. (Courtesy Kay Mahoney, daughter of Matt Adgie.)

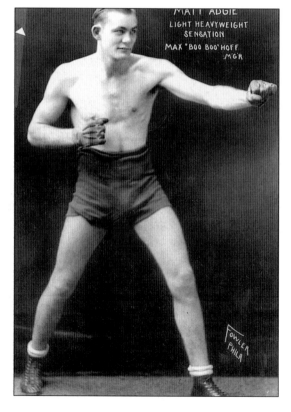

THE "WYALUSING FIGHTING ICEMAN." Light heavyweight Matt Adgie got this moniker because he lived and hung out on Wyalusing Avenue in Philadelphia and was an iceman. Once while fighting he decided to stop working on the ice wagon, and his career started to plummet. His trainer realized that the lifting of ice had become part of his training, so he went back to it and his record improved. Adgie was managed by Max "Boo Boo" Hoff, the racketeer. (Courtesy Kay Mahoney, daughter of Matt Adgie.)

A SHIBE PARK PROGRAM. Here is the program for the fight card held at Shibe Park on August 15, 1927. George Godfrey was the featured fighter and was set to take on Jimmy Maloney of Boston.

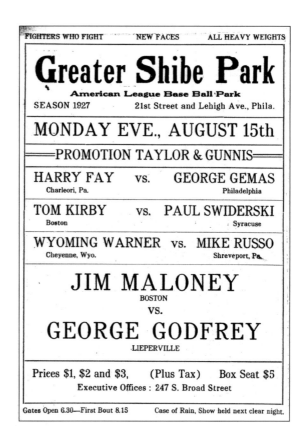

FIGHTERS WHO FIGHT NEW FACES ALL HEAVY WEIGHTS

Greater Shibe Park

American League Base Ball·Park

SEASON 1927 21st Street and Lehigh Ave., Phila.

MONDAY EVE., AUGUST 15th

════PROMOTION TAYLOR & GUNNIS════

HARRY FAY vs. **GEORGE GEMAS**
Charleori, Pa. Philadelphia

TOM KIRBY vs. **PAUL SWIDERSKI**
Boston Syracuse

WYOMING WARNER vs. **MIKE RUSSO**
Cheyenne, Wyo. Shreveport, Pa.

JIM MALONEY
BOSTON
VS.
GEORGE GODFREY
·LIEPERVILLE

Prices $1, $2 and $3, (Plus Tax) Box Seat $5
Executive Offices : 247 S. Broad Street

Gates Open 6.30—First Bout 8.15 Case of Rain, Show held next clear night.

SIGNING FOR THE BATTLE. Benny Bass (seated, left) and "Red" Chapman (seated center) sign for their September 12, 1927 featherweight title bout at Municipal Stadium. It was a great fight that saw Bass take the title. Standing, from left to right, are Harry Farrell (commissioner), Phil Glassman (Bass's manager), Havey Boyle (commissioner from Pittsburgh), Herman "Muggsy" Taylor (co-promoter), Bob Young (secretary of the Pennsylvania Boxing Commission), Bobby Gunnis (co-promoter), and Charlie Cardio (Chapman's manager). Seated beside Chapman is Frank Wiener, chairman of the Pennsylvania Boxing Commission.

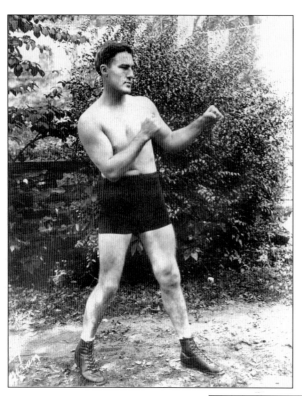

AN ALL-TIME GREAT LIGHT HEAVYWEIGHT. Tommy Loughran defeated Mike McTigue in 15 rounds to win the world light heavyweight championship in New York on October 7, 1927. Loughran was quick, agile, and a wonderful boxer. During his career, which lasted from 1919 to 1937, he engaged in more than 170 bouts.

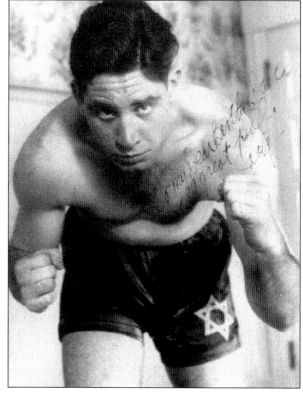

THE JEWISH BOXING BRIGADE. Not much has been written over the years about the outstanding collection of Jewish fighters in Philadelphia, but they compared favorably with any other city. A few members of this talented Philadelphia group included Harry Lewis, Battling Levinsky, Benny Bass, Lew Tendler, Louisiana, Harry Blitman, Eddie O'Keefe, Mike Rossman, Eddie "Kid" Wagner, Gussie Lewis, Joe Tiplitz, Danny Kramer, Harry "Kid" Brown, Nate Goldman, Al Gordon, Yankee Schwartz, Sammy Smith, "Young" Sammy Smith, Benny Kaufman, Frankie Bradley, Bobby Burman, Joe Hirst, Marty Gold, Harry Smith, Al Winkler, Happy Davis, Marvin Edelma, Barney Ford, Harry Rubin, Dave Adelman, Harry Serody, Nate Brown, and Jack Gross (pictured). (Courtesy Parry Desmond.)

SAMMY AND THE BABE. Sammy Mandell (left), a lightweight whiz, and South Philadelphia's own Babe Ruth (Anthony Scattino) weigh in for their November 23, 1927 bout at the Philadelphia Armory. Mandell won a 10-round decision.

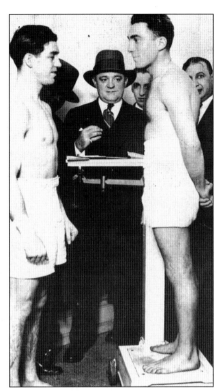

LEFT-HANDED LEW. Lew Tendler is ready for a little sparring action. Tendler was one of the great Jewish fighters of the 1920s. (Courtesy Antiquities of the Prize Ring.)

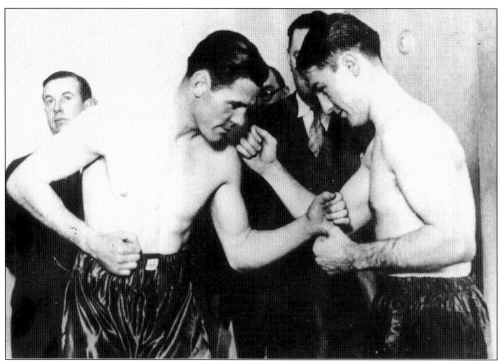

SQUARING OFF. The brilliant boxer Tommy Loughran (right) poses at the weigh-in with challenger Jimmy Slattery prior to their light heavyweight championship bout in New York on December 12, 1927. Loughran won in 15 rounds. (Courtesy J.J. Johnston.)

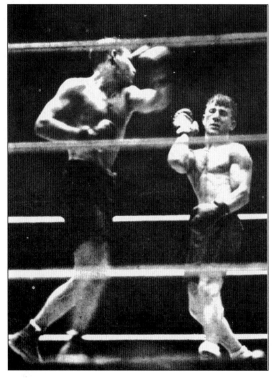

TONY BEATS BENNY. Tony Canzoneri defeated Benny Bass (right) in 15 rounds in New York on January 10, 1928, for the world featherweight championship. Bass staged one of the most courageous comebacks in boxing history when, after his collarbone was broken in round three, he managed a big rally late in the bout to almost overcome Tony's early lead.

A FEATHERWEIGHT SENSATION.
Unbeaten Harry Blitman upset champion
Tony Canzoneri at the Baker Bowl on
June 27, 1928, to set up a match with
the former champion Benny Bass at
Shibe Park in September for Philadelphia
bragging rights. (Courtesy Antiquities of
the Prize Ring.)

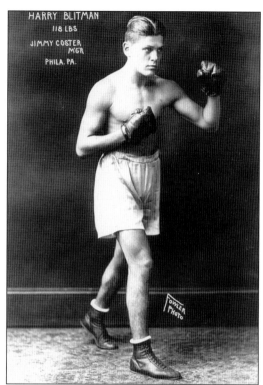

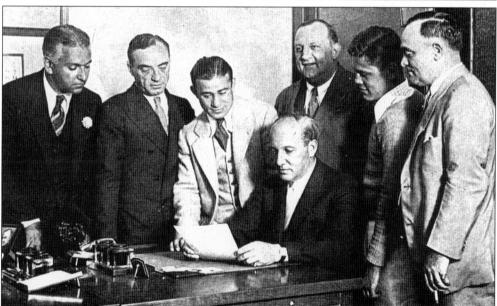

THE PENNSYLVANIA FEATHERWEIGHT TITLE. Benny Bass and Harry Blitman sign for their
September 10, 1928 bout for the state title. Standing, from left to right, are Bernard Lemish,
representing Phil Glassman and Max "Boo Boo" Hoff (Bass's managers); Herman "Muggsy"
Taylor, co-promoter; Benny Bass; Bobby Gunnis, co-promoter; Harry Blitman; and Robert
Young, secretary of the Pennsylvania Boxing Commission. Seated at the table is Frank Wiener,
commissioner. Bass won by a stoppage in six rounds.

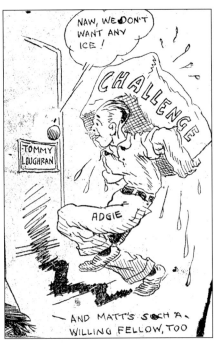

LOUGHRAN REFUSES TO FIGHT ADGIE. On April 21, 1929, the *Philadelphia Record* reported that Tommy Loughran turned down $25,000 to fight Matt Adgie, the "Wyalusing Fighting Iceman." (Courtesy Kay Mahoney, daughter of Matt Adgie.)

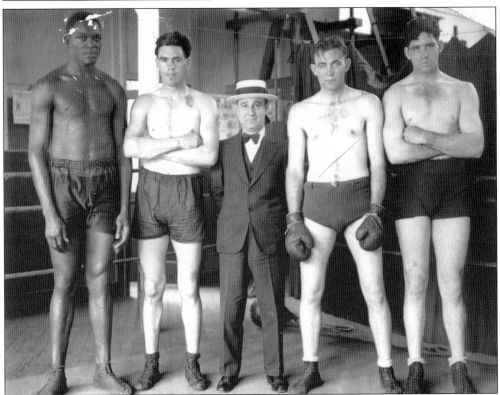

MAX AND HIS STABLE. The year is 1929, and Max "Boo Boo" Hoff is shown standing with four of his fighters. From left to right are Roy "Ace" Clark, Tom Toner, Max Hoff, Matt Adgie, and Jack Gross. (Courtesy Temple University Libraries, Urban Archives.)

Five

1930–1939

The Great Depression hit local boxing as hard as it did the rest of the world. Promoters Herman "Muggsy" Taylor and Bobby Gunnis continued running a fairly profitable operation at the newly opened Convention Hall along with their outdoor shows.

Jimmy Toppi kept the Broadway open until 1935 and then switched to the smaller Olympia Athletic Club. He also felt confident enough later in the decade to open the 5,500-seat Met.

Fried and Fishman struggled at the Philadelphia Arena until Max "Boo Boo" Hoff took over in 1936. Running his penny-a-round, 40-rounds-for-40¢ experiment encouraged him enough to eventually go to 52 rounds for 52¢. Johnny Burns's Cambria continued as a Friday night staple in Northeast Philadelphia.

What these clubs contributed most importantly were venues to develop a constant flow of depression-tough, hungry fighters. Philadelphia remained in the boxing spotlight with imaginative matchmaking and battle-tested fighters. Champions like the peerless flyweight king Midget Wolgast, junior lightweight boss Benny Bass, and top heavyweights including Tommy Loughran, George Godfrey, Al Ettore, Leroy Haynes, Jersey Joe Walcott, Willie Reddish, and Gus Dorazio were big attractions.

The Quaker City continued as a lightweight hotbed with such highly rated men as Lew Massey, Tony Falco, Tony Morgano, Jackie Willis, Johnny Jadick, Georgie Gibbs, Benny Bass, Young Firpo, and Eddie Cool involved in an exciting round robin of crosstown rivalries and neighborhood feuds. These continued to the end of the decade, when the emergence of Tommy Cross, Johnny Hutchinson, Mike Evans, and Bob Montgomery replaced the "old guard."

As war clouds rumbled across Europe and Asia, Philadelphia boxing was about to encounter another crisis.

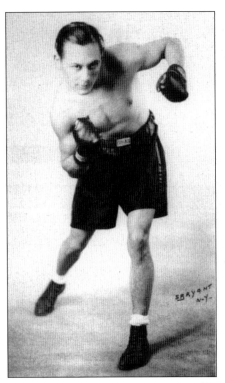

HE WAS FAST. Midget Wolgast, whose real name was Joseph Robert LoScalzo, was an all-time great flyweight who fought from 1925 to 1940. Some said he was so fast in his workouts that his shadow had a tough time keeping up with him. Wolgast won the New York State version of the world flyweight championship on March 21, 1930, when he defeated Black Bill in 15 rounds. He followed up that victory with a 6-round stoppage of Willie LaMorte on May 16, 1930, in New York for the title. (Courtesy Antiquities of the Prize Ring.)

THE CALL NEVER CAME. Tony Falco was an amateur champion who turned pro and fought more than 200 bouts. After victories over Jackie "Kid" Berg, "Young Peter" Jackson, Bobby Pacho, and a number of others, Falco, of South Philadelphia, became the No. 1 contender for the junior welterweight title, but a promised shot at champion Barney Ross never materialized. Falco is shown weighing in against Ernie Ratner at Virginia Beach c. 1930. He won a 10-round decision.

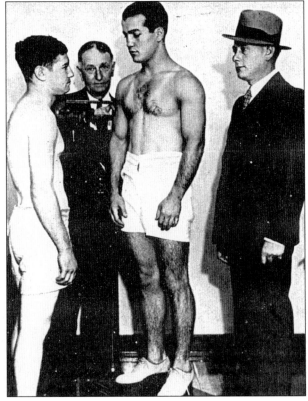

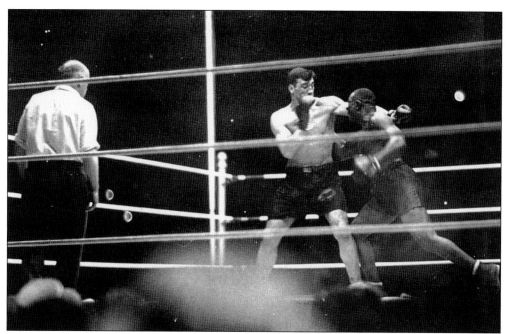

DYNAMITE IN BIG PACKAGES. George Godfrey (right) attacks Primo Carnera in their bout of June 23, 1930, at the Baker Bowl. Carnera won when Godfrey was disqualified for a low blow in the fifth round. Godfrey lost his license and the purse for the evening. (Courtesy J.J. Johnston.)

THE UNCROWNED CHAMPION. Due to the racial climate of the time, George Godfrey was acclaimed as the "colored heavyweight champion of the world" and the "uncrowned champion." He was Philadelphia's greatest box office attraction from 1924 to 1930. (Courtesy Bob Carson.)

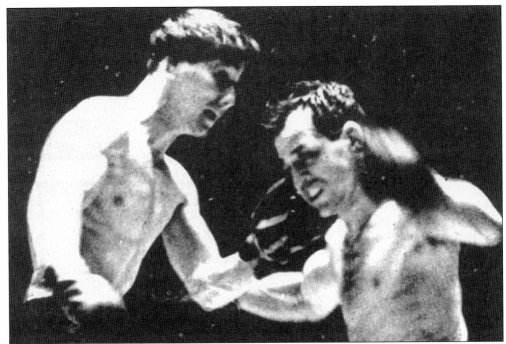

EVENLY MATCHED. Two champions, Philadelphia's Midget Wolgast (left) and Frankie Genaro, reigned in the flyweight division in 1930. Fans could not decide who was better. Finally, they got together in New York on December 26, 1930. The result was a draw in 15 rounds.

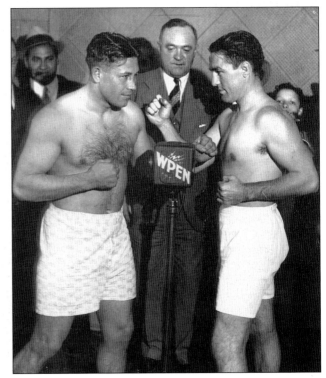

A PREFIGHT POSE. Tommy Loughran (right) and Johnny Risko weigh in before their October 19, 1931 bout at the Philadelphia Arena. Loughran won a 10-round decision.

KID CHOCOLATE. A great fighter and champion, the Kid fought more than 150 bouts in his 10-year career. During this time, he held the junior lightweight world championship and the New York version of the world featherweight title. He had three junior lightweight title fights in Philadelphia. On July 15, 1931, he stopped Benny Bass in seven rounds at the Baker Bowl. On May 1, 1933, he beat Johnny Farr at the Philadelphia Arena in 10 rounds. He lost the title to Frankie Klick by a seventh-round knockout on December 25, 1933, at the Philadelphia Arena. (Courtesy Antiquities of the Prize Ring.)

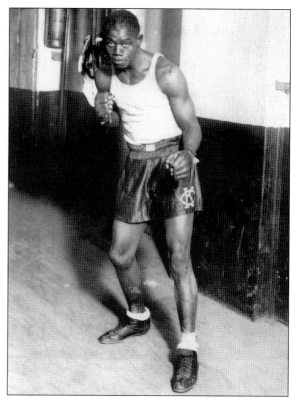

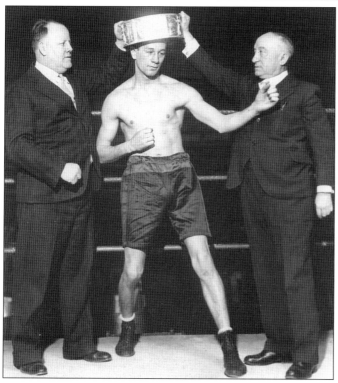

CROWN THE KING. Longtime journeyman Johnny Jadick poses with his trainer, Joe Ferguson (left), and manager, Johnny Burns. Jadick won the junior welterweight championship by defeating Tony Canzoneri in 10 rounds at the Philadelphia Arena on January 18, 1932.

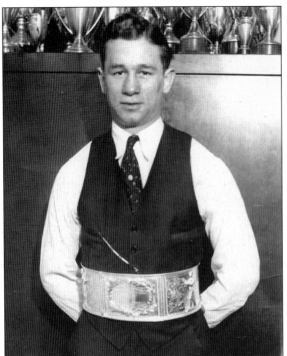

PROUD OF THE BELT. Johnny Jadick, from the Kensington section of Philadelphia, proudly displays the championship belt he was awarded after his upset win over the great Tony Canzoneri for the junior welterweight championship title.

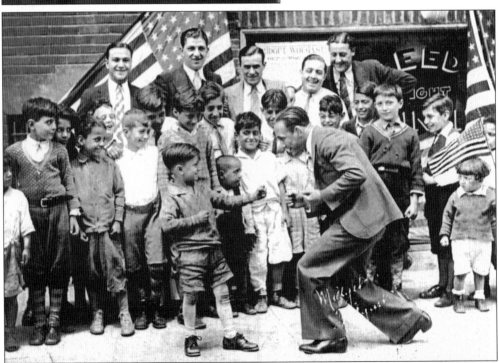

PUT UP YOUR DUKES, KID. World flyweight champion Midget Wolgast, seen sparring with a young admirer, was a hero to the depression-era children of South Philadelphia. Midget was called the "fastest fighter of all time" by many scribes and was considered to be the "Willie Pep" of his day.

MAX HOFF IN FEDERAL COURT. Boxing promoter, manager, and former rackets boss Max "Boo Boo" Hoff (left, wearing a bow tie) was arrested for passing counterfeit bills at the 30th Street railroad station. Here, he is shown in federal court at a hearing in January 1934. Hoff remained in the fight game until his death in 1941. (Courtesy Temple University Libraries, Urban Archives.)

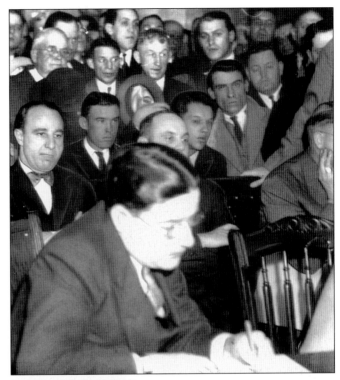

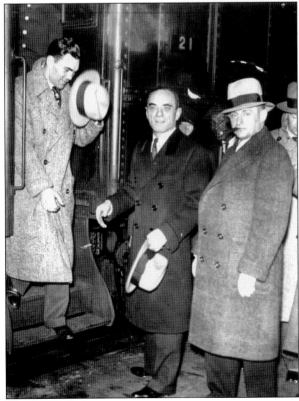

THE FORMER CHAMPION ARRIVES IN TOWN. Former heavyweight champion Max Schmeling is greeted at the train station by Herman Taylor and Joe Jacobs, his manager, prior to the fight with Steve Hamas at Convention Hall on February 13, 1934. Schmeling lost a 12-round decision. (Courtesy Temple University Libraries, Urban Archives.)

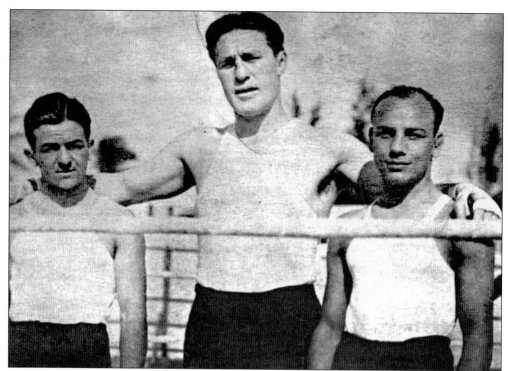

TOMMY'S LITTLE HELPERS. Tommy Loughran is shown with two of his sparring partners, Joe Maffei (left) and Dick Welsh (right), prior to his Miami fight with Primo Carnera on March 1, 1934.

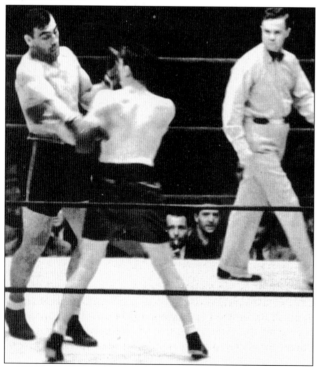

JUST A LITTLE TOO BIG. Tommy Loughran (back to camera) challenged huge Primo Carnera for the heavyweight championship but was unsuccessful in 15 rounds. The 86-pound weight advantage for Carnera was too much for Loughran to overcome.

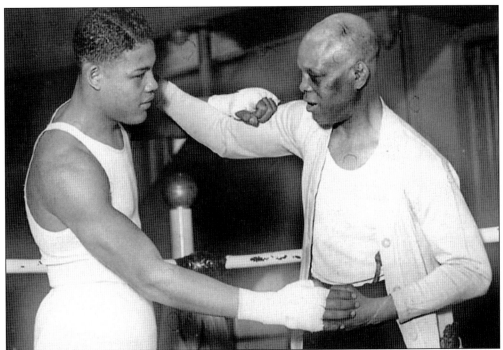

A WINNING TEAM. Joe Louis receives instruction from his trainer, Jack "Chappie" Blackburn. Blackburn was like a father to Louis and always gave him good, solid advice. Louis listened. (Courtesy Antiquities of the Prize Ring.)

A LONGTIME TOP CONTENDER. South Philadelphia's Lew Massey (Massucci) and opponent Leonard Del Genio (left) of Harlem pose for the camera. Massey was a top contender in both the featherweight and lightweight divisions. Patsy Nelson stands between them. (Courtesy Rich Pagano.)

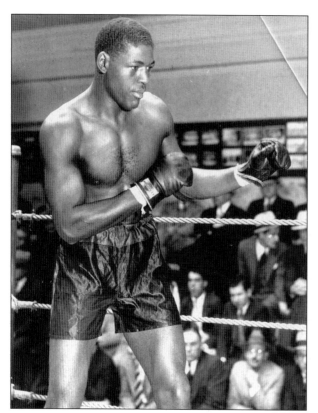

LEROY HAYNES. An Indiana man who fought out of Philadelphia, Leroy Haynes was one of the most feared heavyweights for a while. He knocked out Primo Carnera twice in 1936—March 16 at Convention Hall and May 27 in Brooklyn. Haynes had three rousing fights against Al Ettore during 1935 and 1936. The two men went 37 rounds against each other.

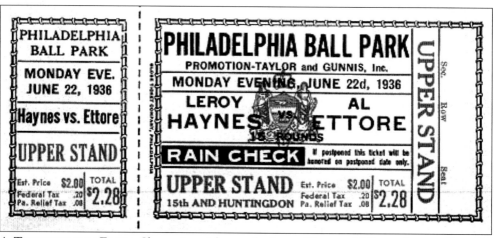

A TICKET TO THE FIGHT. Shown is a ticket to the Leroy Haynes–Al Ettore bout on June 22, 1936, at Philadelphia's Shibe Park. (Courtesy Antiquities of the Prize Ring.)

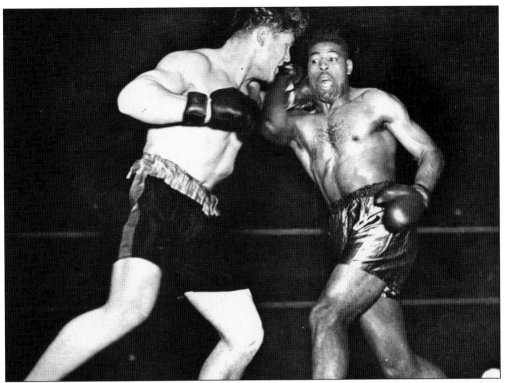

AL ETTORE AND LEROY HAYNES FIGHT THREE TIMES. This photograph is from one of the Ettore-Haynes bouts. Ettore (left) launches a left that Haynes avoids. Ettore won all three contests.

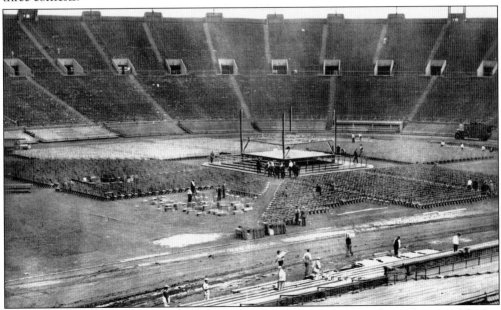

CONSTRUCTING THE RING FOR THE BIG FIGHT. This is Municipal Stadium, the site of the Joe Louis–Al Ettore fight on September 22, 1936. Workmen are busy assembling the ring. Louis stopped Ettore in round five. (Courtesy Temple University Libraries, Urban Archives.)

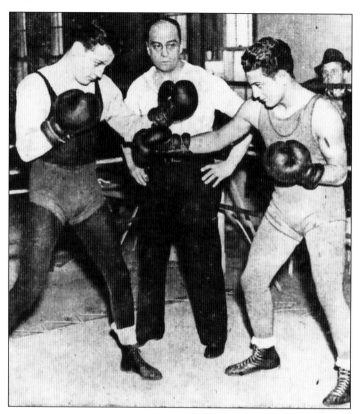

THE WATCHFUL EYE. Famed Philadelphia trainer Jimmy Coster watches lightweight contender Eddie Cool (left) spar with Frankie Mills in preparation for Cool's nontitle bout with champion Lou Ambers at the Philadelphia Arena on October 28, 1936. Cool scored an upset victory over the champion. Eddie Cool was one of the most brilliant boxers ever from Philadelphia, but his total lack of discipline prevented him from ever wearing a crown.

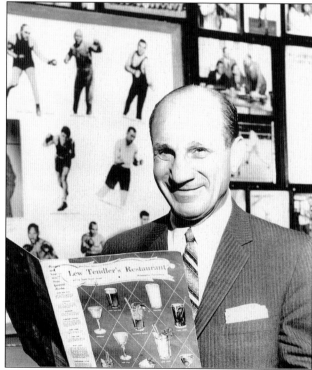

AN EYE FOR BUSINESS. With a smile, Lew Tendler examines the menu at his restaurant on Broad Street. The great fighter became a shrewd businessman. (Courtesy Rich Pagano.)

BIG AL WEIGHS IN WITH JOHN HENRY. Al Ettore (right) and John Henry Lewis weigh in for their January 4, 1937 bout at Convention Hall. Ettore was first declared the winner, but the commissioner overruled officials and the bout was declared a draw. (Courtesy Antiquities of the Prize Ring.)

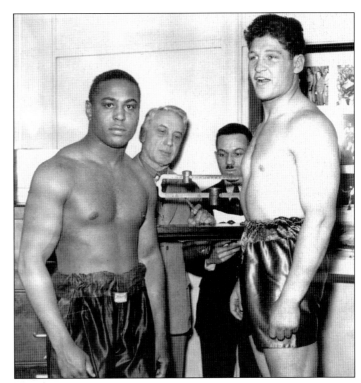

THE POPULAR TWO-TON MAN. Tony Galento (left) fought in Philadelphia several times during his career. Galento always came to fight and scored seven knockouts in Philadelphia rings. He is shown with his manager, Joe Jacobs and former heavyweight king Max Schmeling.

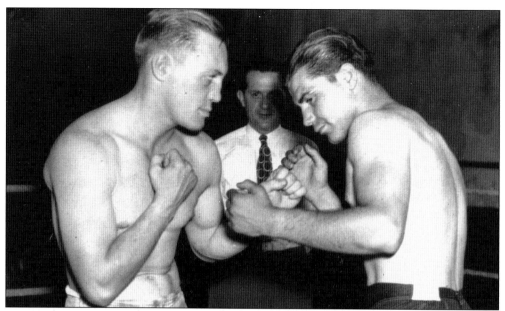

NOW OR LATER. Billy Ketchell, the Millville, New Jersey "Plowboy," squares off with South Philadelphia's Gus Dorazio (right) before one of their matches in 1937. Dorazio was the top spoiler of the heavyweight division during his 1935–1946 career, with upset wins over Bob Pastor, Harry Bobo, "Wild Bill" Boyd, Buddy Walker, Joe Baksi, Al Hart, and Lem Franklin. His loss to Curtis "Hatchetman" Sheppard in Pittsburgh on January 24, 1944, caused a scandal since Dorazio won eight of the ten rounds fought.

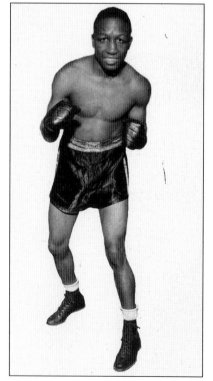

AN UP-AND-DOWN CAREER. Johnny Hutchinson boxed in Philadelphia for the first years of his career and then traveled to Australia and New Zealand, where he boxed for the next two years. He then went to California for a year and then back home to Philadelphia for the last two years of his fistic wars. His career was up and down, but he always gave it his all.

THE BAKER BOWL. The old place provided much excitement for the hometown sports crowd, but it is on the way out. This is a scene from one of the last events held there in 1938. (Courtesy Temple University Libraries, Urban Archives.)

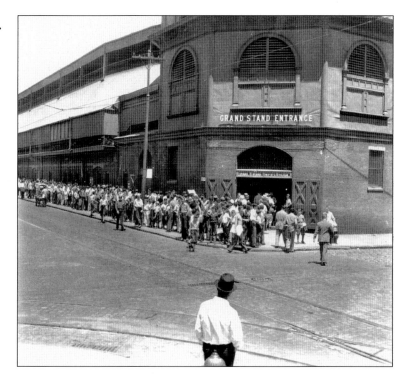

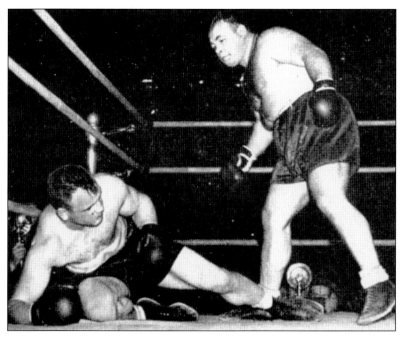

WANT SOME MORE, BUB? Tony Galento (right) floors Harry Thomas in the third round at Convention Hall on November 14, 1938. Almost a year later, on September 15, 1939, at Municipal Stadium, Galento stopped Lou Nova in 14 rounds in what many boxing people consider the "dirtiest fight of all time."

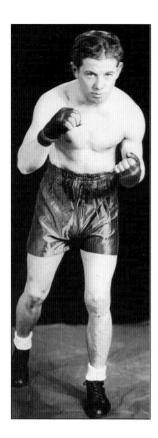

IRISH JIMMY. Nicetown's Jimmy Tygh was an aggressive lightweight contender in 1939. He defeated Tony Canzoneri in ten rounds on May 1, 1939, at the Philadelphia Arena. He also knocked out Eddie Cool in four rounds at Philadelphia on October 18, 1939. Tygh added a ten-round win over Benny Bass to his credit on March 4, 1940.

RIVALRIES. Ethnic and racial rivalries were the staple for successful fight clubs in the city. This poster calls for all South Philadelphia boxing fans to support their Italian countryman Tony Sarullo against Jewish opponent Tommy Spiegel on November 23, 1939.

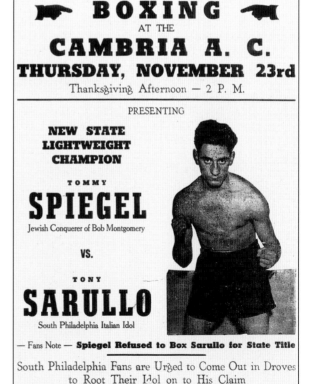

Six

1940–1949

By 1940, a world war seemed imminent, but it was business as usual in the fight game. South Philadelphia Italians Tommy Forte and Gus Dorazio had unsuccessful shots at world champions—bantamweight Lou Salica and heavyweight Joe Louis, respectively.

When war was declared, a large group of top fighters interrupted their careers to serve their country. In August 1942, the war really hit home as popular local club fighter Johnny Rivers became a hero on Guadalcanal with fellow Philadelphian Al Schmid in an episode that was immortalized in the movie *The Pride of the Marines*. Unfortunately, Rivers lost his life, but the fighting spirit of Philadelphia was demonstrated to the highest degree.

War workers earning good wages ushered in the latest boom in local boxing by attending the many great shows put on by Herman Taylor at Convention Hall and Shibe Park and the Toppis at the Met. The performances at the Cambria established Frank "Blinky" Palermo as a power behind the scenes after Johnny Burns's death in 1940.

Bob Montgomery's feud with Ike Williams had the whole town talking. The "teenage boxing sensations"—Wesley Mouzon, Billy Arnold, Billy Fox, and Clarence "Honeychile" Johnson—replaced many of the boxers who came back from the war ill prepared to carry on, with pressing family responsibilities, after their long absences.

As Jimmy Toppi opened a beautiful new outdoor boxing arena at Broad and Packer in 1948, another threat to local boxing appeared: television.

HE UPSET THE CHAMPION. The stiff-hitting Southwark bantam Tommy Forte upset champion Lou Salica on October 22, 1940, at the Philadelphia Arena in a nontitle contest that forced a championship bout three months later.

BRUISED AND BATTERED BUT STILL CHAMPION. After 15 gruelling rounds, Lou Salica retained his bantamweight crown on a razor-thin decision against his South Philadelphia challenger, Tommy Forte, on January 13, 1941, at the Philadelphia Arena. Salica had his eye completely closed at the end. He edged Forte again at Shibe Park in June.

REUNION. Two old-timers, Benny Leonard and Lew Tendler (right), get together for an exhibition at Convention Hall on February 4, 1941.

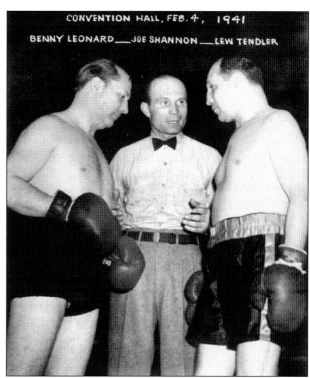

CONVENTION HALL, FEB. 4, 1941

BENNY LEONARD___JOE SHANNON___LEW TENDLER

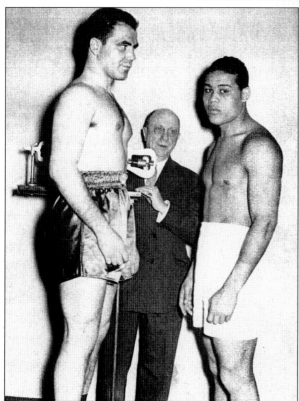

THE WEIGH-IN. Joe Louis and Gus Dorazio (left) weigh in for their February 17, 1941 heavyweight title bout at Convention Hall. Louis, the Brown Bomber, was on target, and the contest lasted only two rounds.

85

THE PHILADELPHIA BOBCAT. Bob Montgomery of North Philadelphia was one of the city's greatest fighters and was a lightweight champion. He was a perpetual-motion buzz saw. His matches with Ike Williams, Beau Jack, Fritzie Zivic, and Sammy Angott were highlights of the hectic 1940s.

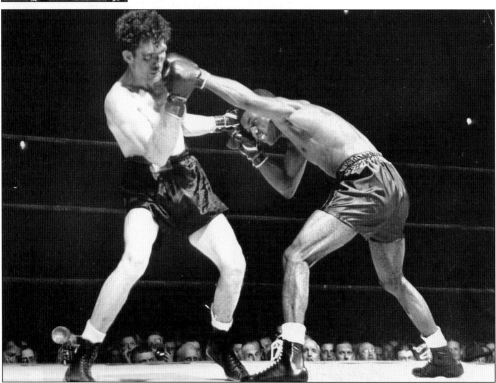

MONTGOMERY BEATS JENKINS. Bob Montgomery (right) avenges an earlier loss to Lew Jenkins by scoring a 10-round decision over Jenkins in New York on May 16, 1941.

A GOOD START, A GOOD CAREER. South Philadelphian Eddie Giosa, a lightweight, began his career in 1943 with a bang, 16-0. During his career, he was lightweight champion of Pennsylvania and boxed nine world champions. Among the men he defeated were Bob Montgomery, Lew Jenkins, Carmen Basilio, Percy Bassett, Charley Fusari, Lulu Constantino, and Johnny Greco.

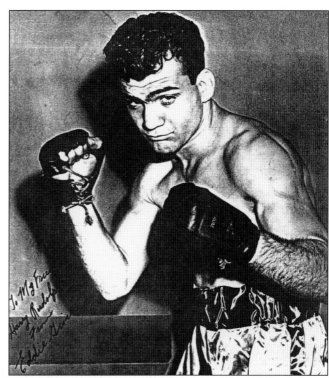

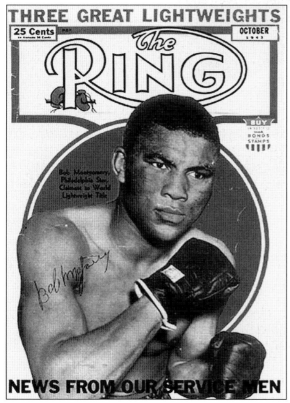

THE OCTOBER COVER BOY. Bob Montgomery won nine bouts by late August 1943, including a title bout win over Beau Jack on May 21 in New York. His performance earned for him the cover of the *Ring* magazine in October 1943. (Courtesy Antiquities of the Prize Ring.)

A Sure Thing. Wesley Mouzon began boxing in 1944 and had accumulated a 22-2-1 record when he faced Bob Montgomery in a nontitle fight in Philadelphia on August 19, 1946. Mouzon won by a knockout in two rounds.

The Bobcat Knocks Out Mouzon. Bob Montgomery (back to camera) avenged his earlier loss and knocked out Wesley Mouzon at Convention Hall in eight rounds on November 26, 1946, to retain his world lightweight championship.

THE CHAMPION PREVAILS.
Gus Lesnevich knocked out
Philadelphian Billy Fox (right)
in New York on February 28,
1947, for the light heavyweight
championship. Fox had scored
43 straight knockouts.

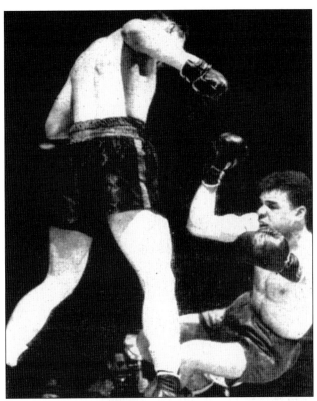

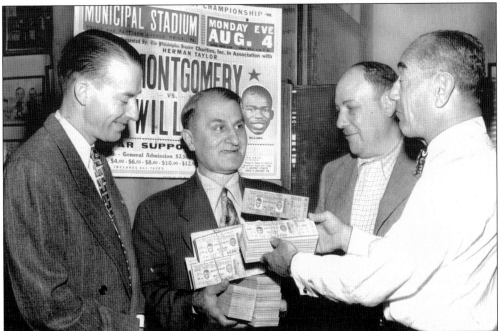

HOW ABOUT SOME TICKETS? Herman Taylor (right), promoter of the Montgomery-Williams title bout, hands tickets to Joe Manze of Trenton, with instructions to go back home and sell them. (Courtesy Temple University Libraries, Urban Archives.)

89

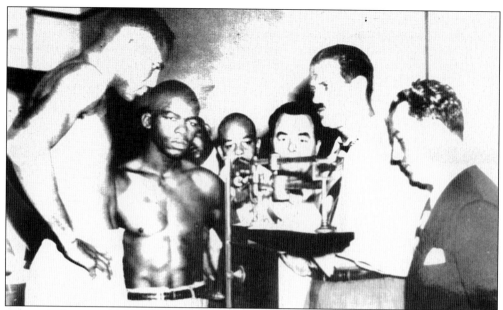

ON THE SCALES. Bob Montgomery (left) weighs in for the lightweight championship bout on August 4, 1947, against Ike Williams (second from left), who looks on. (Courtesy J.J. Johnston.)

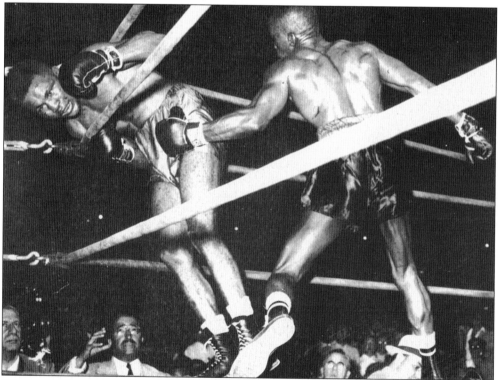

WILLIAMS TAKES THE CROWN. Ike Williams batters champion Bob Montgomery into the ropes on his way to capturing the title at Municipal Stadium, thus avenging his previous defeat by Montgomery and settling their bitter feud. More than 30,000 fans attended.

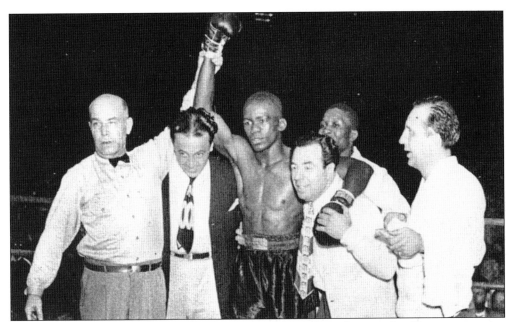

THE WINNER AND NEW CHAMPION. Ike Williams, from Brunswick, Georgia, came to Philadelphia and became a great crowd pleaser and a great fighter. Here we see his hand raised in victory after knocking out Bob Montgomery. With Willaims, from left to right, are referee Charlie Daggert, Frank Palumbo, Frank "Blinky" Palermo, Jesse Goss, and Jimmy Wilson. (Courtesy George Silvano, son of Jimmy Wilson.)

IKE WILLIAMS RETAINS THE TITLE. Ike Williams (right) gave Beau Jack a shot at the lightweight championship on July 12, 1948, at Shibe Park. Jack came out swinging, but Williams stopped him in round six.

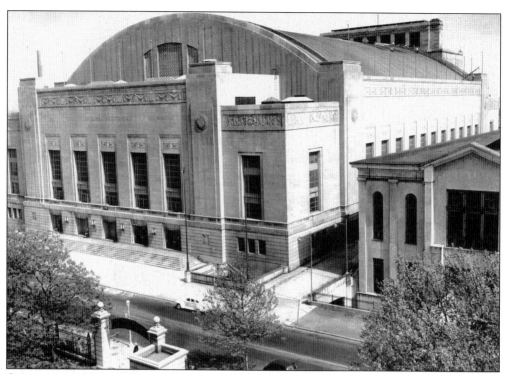

CONVENTION HALL. Many a fight was held here over the years. It was a major site for big bouts of the time. This photograph was taken in 1948. (Courtesy Temple University Libraries, Urban Archives.)

HONEY CHILE. Clarence Johnson, a welterweight and middleweight, was a frequent Philadelphia attraction during the late 1940s and early 1950s. His most notable bouts were five contests against Charley Spicer, three against Otis Graham, and his fights with Rocky Graziano and Johnny Saxton.

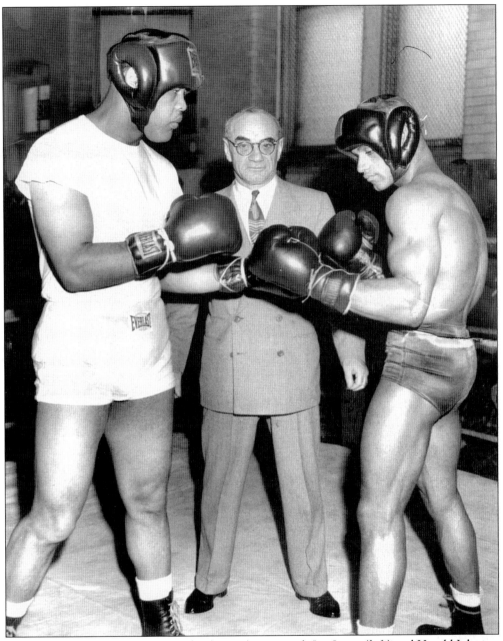

THREE GREAT ONES. Herman Taylor (center) poses with Joe Louis (left) and Harold Johnson on December 13, 1948, in Philadelphia, a day before their scheduled bouts. Louis boxed a six-round exhibition with Arturo Godoy, and Johnson knocked out Willie Brown in seven rounds. (Courtesy Temple University Libraries, Urban Archives.)

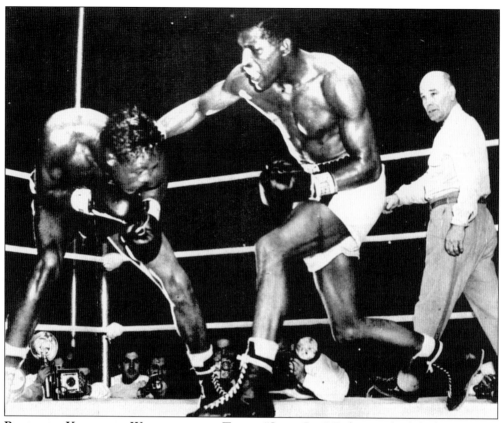

ROBINSON KEEPS THE WELTERWEIGHT TITLE. "Sugar Ray" Robinson (right) defeated Kid Gavilan in 15 rounds at Municipal Stadium before 27,000 fans on July 11, 1949, to retain the world welterweight championship.

WILLIAMS BEATS DAWSON. On December 5, 1949, at Convention Hall, Ike Williams (left) defeated Freddie Dawson, one of the most feared Chicago fighters, in 15 rounds for the lightweight championship.

Seven

1950–1959

Even as the local small clubs struggled to compete with nationally televised boxing from Madison Square Garden, they still continued to produce top-flight talent for the city's bigger venues.

Harold Johnson, Joey Giardello, and Percy Bassett became real threats to the champions in their divisions, along with "Philly Phenoms" Gil Turner, "Sugar" Hart, and Len Matthews. Sugar Ray Robinson won the Pennsylvania version of the world middleweight title at Municipal Stadium in June 1950, defeating Frenchman Robert Villemain. He strengthened his claim in October by knocking out Bobo Olson in 12 rounds at Convention Hall.

The year 1952 brought the greatest summer in Philadelphia boxing history as 101,000 fans viewed three world title matches at Municipal Stadium—the June match between heavyweight champion Jersey Joe Walcott and Ezzard Charles, as Zack Clayton became the first black to referee a heavyweight championship contest; Kid Gavilan stopping Gil Turner after 11 savage rounds in July; and Rocky Marciano's electrifying knockout of Walcott on September 23.

Unable to compete with television boxing, the Toppis closed the Met and their outdoor arena in 1954. The Cambria barely carried on, but Jimmy Riggio helped keep the game alive by opening the Plaza and later the Alhambra in South Philadelphia.

The sport was banned for 114 days by Gov. George Leader in 1955 after the infamous "poisoned orange incident," involving Harold Johnson's shocking knockout by underdog Julio Mederos on national television. Mythic Philadelphia gym wars were gaining notoriety throughout the boxing world during this period, and Frank "Blinky" Palermo moved a ferocious heavyweight named Sonny Liston into town.

The last major outdoor show held at a Philadelphia ballpark (Connie Mack Stadium) took place in June 1958, when Gil Turner and Sugar Hart battled to a draw. Fittingly, Herman Taylor, who started it all at the same venue 41 years previously, promoted the card.

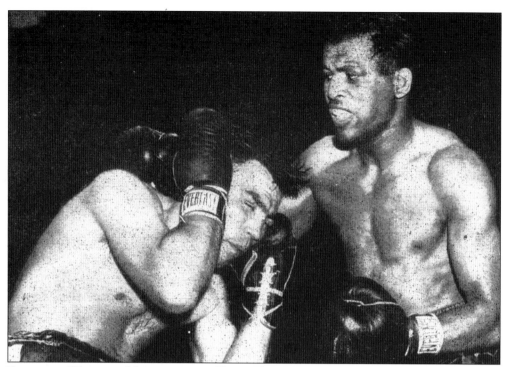

ROBINSON WINS THE MIDDLEWEIGHT TITLE. On June 5, 1950, Sugar Ray Robinson (right) beat Robert Villemain of France in 15 rounds at Municipal Stadium to win the Pennsylvania version of the world middleweight championship.

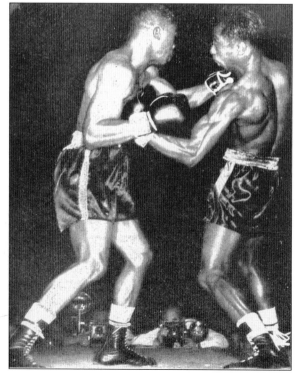

SLOWING DOWN. Ike Williams (left) showed signs of slipping on July 12, 1950, when he lost a 10-round decision to George Costner at Shibe Park.

A DEADLY BLOW. On December 20, 1950, Percy Bassett (right) stopped "Sonny Boy" West in seven rounds at New York. West died as the result of injuries sustained during the bout.

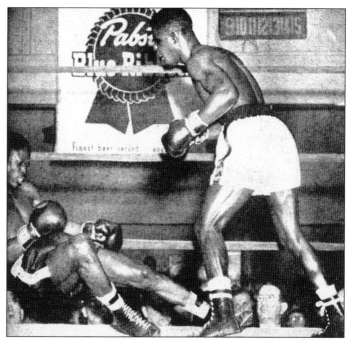

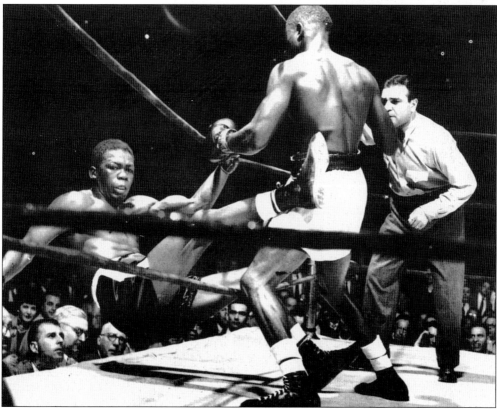

THIS IS IT. Jimmy Carter stopped Ike Williams (left) in the 14th round of their May 25, 1951 lightweight championship bout in New York to win the crown.

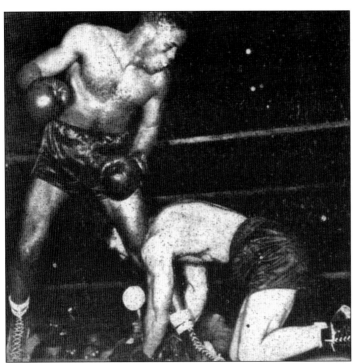

TURNER BEATS FUSARI.
Gil Turner floors
Charley Fusari in their
July 9, 1951 bout at
Shibe Park. Turner
won by a knockout in
round 11.

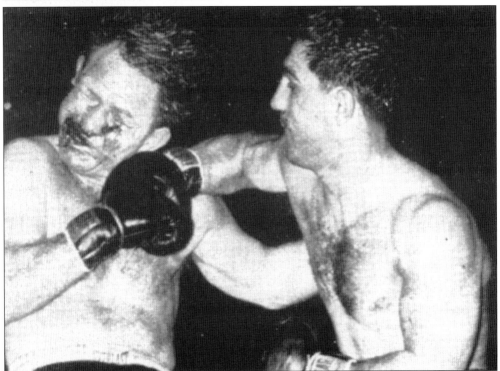

ONE MORE FOR GOOD MEASURE. Rocky Marciano (right) brought his guns to town on February 13, 1952, at Convention Hall. Lee Savold was waiting for him. The two battled it out for six rounds before Marciano stopped Savold. Here, Marciano slams a right to Savold's chin.

THE GREATEST SEASON. The greatest outdoor season in Philadelphia history was in 1952, when three world title fights were held at Municipal Stadium. Pictured is the program for the Jersey Joe Walcott–Ezzard Charles bout on June 5.

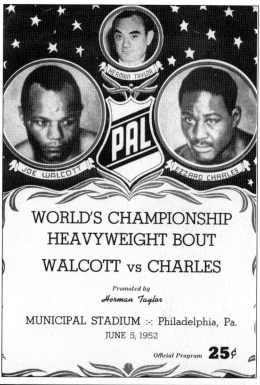

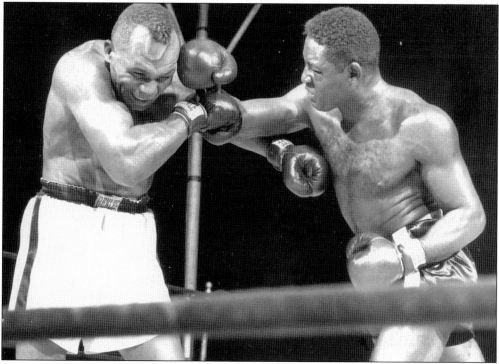

CHAMPIONSHIP ACTION. Ezzard Charles lands a right-hand blow to the temple of Jersey Joe Walcott in the June 5, 1952 title bout. Walcott retained his crown with a 15-round decision.

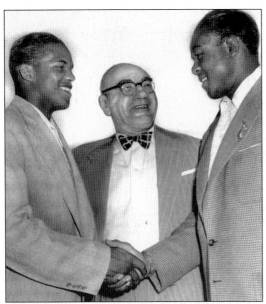

TURNER MEETS GAVILAN. Gil Turner (left) of Strawberry Mansion in North Philadelphia shakes hands with champion Kid Gavilan, as Herman Taylor looks on. They met for Gavilan's welterweight title on July 7, 1952, at Municipal Stadium. Gavilan won in 11 rounds. The bout was held before 39,000 fans. (Courtesy Temple University Libraries, Urban Archives.)

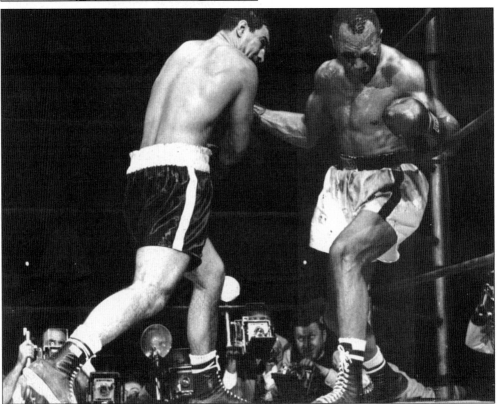

OVER AND OUT. Rocky Marciano (left) lands a haymaker right to the jaw of champion Jersey Joe Walcott. Longtime Philadelphia promoter Herman Taylor called it "the greatest heavyweight fight I ever looked at." Some 40,300 fans watched Marciano score his electrifying 13th-round knockout of Walcott on September 23, 1952, at Municipal Stadium to capture the world heavyweight championship.

LISTEN HERE, BLINKY. Is Jack Dempsey (left) telling South Philadelphia racketeer Frank "Blinky" Palermo to get out of boxing? Palermo, Frankie Carbo's top lieutenant, had the largest stable of fighters in the game and controlled the powerful Manager's Guild during the 1950s.

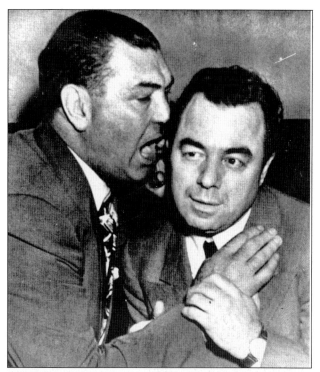

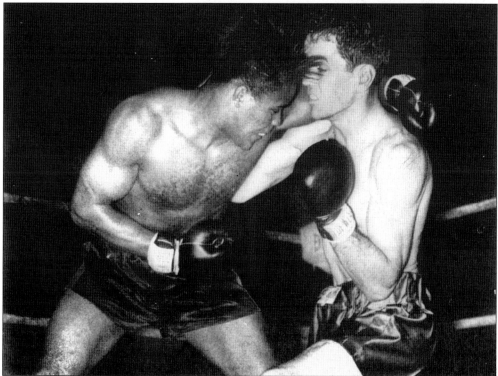

MAY I HAVE THIS DANCE? Gil Turner (left) defeated Bobby Dykes at the Philadelphia Arena on January 20, 1953, in 10 rounds to avenge an earlier loss to Dykes.

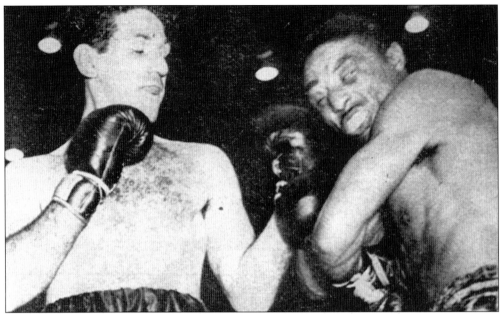

A Fight for Life. From 1949 to 1976, one of the highlights of Philadelphia boxing was the annual Deborah Hospital Fight for Life Benefit Show, run by Jack Liessor and Jack Puggy. Here, Dan Bucceroni (left) delivers an uppercut to Rocky Jones at the Philadelphia Arena on January 27, 1953. Bucceroni won in 10 rounds. Jones had recently scored an upset win over Roland LaStarza. More than $100,000 was raised for the hospital. Bucceroni was in line for a shot at champion Rocky Marciano in January 1954, but Marciano's manager, Al Weill, canceled the match for some unknown reason.

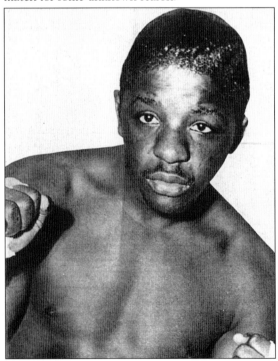

An All-Out Action Slugger. Percy Bassett of West Philadelphia won the interim featherweight title by knocking out Ray Famechon in three rounds at Paris on February 9, 1953. He was promised a shot at Sandy Saddler's title for the undisputed championship, but Saddler's management refused to let their man fight Bassett.

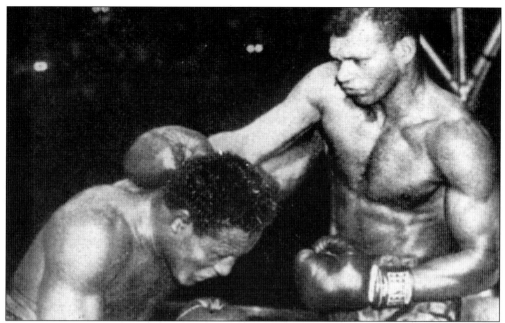

NOTHING LIKE A GOOD RIGHT HAND. Harold Johnson (right) scored a close decision over former heavyweight champion Ezzard Charles on September 8, 1953, at Connie Mack Stadium in an exciting 10-rounder. After the bout Johnson challenged heavyweight king Rocky Marciano and light heavyweight champion Archie Moore.

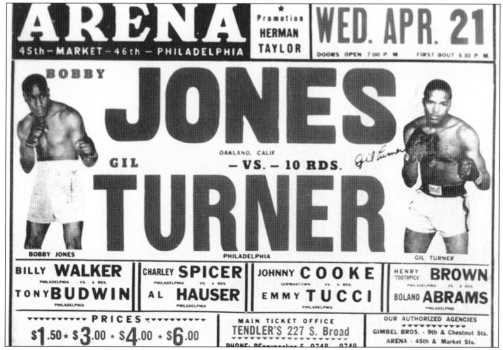

A FIGHT POSTER. Gil Turner lost to Bobby Jones in 10 rounds at the Philadelphia Arena on March 10, 1954. A rematch was scheduled for the same place on April 21, 1954. (Courtesy Antiquities of the Prize Ring.)

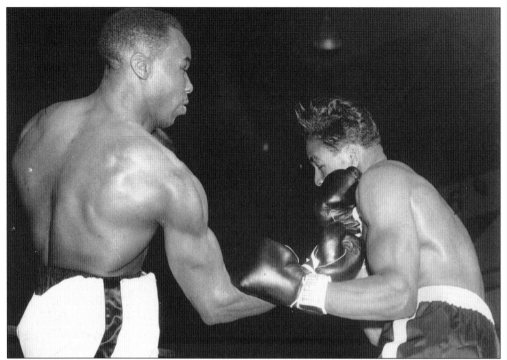

JONES AND TURNER. Bobby Jones throws a right to Gil Turner in their April 21, 1954 bout at the Philadelphia Arena. This time, Jones stopped Turner in the 10th round.

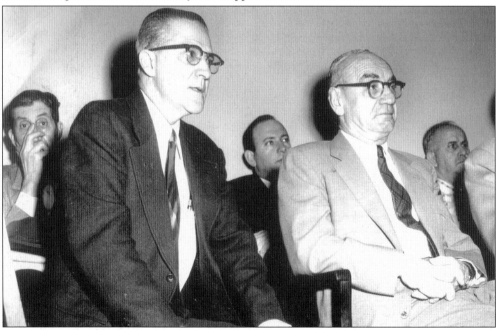

TRYING TO MUSCLE IN. Archie Pirolli (front left) and Herman Taylor (front right) appear before the state athletic commission for allegations of conspiring to take over the management of Trenton middleweight George Johnson. Pirolli refused to testify. (Courtesy Temple University Libraries, Urban Archives.)

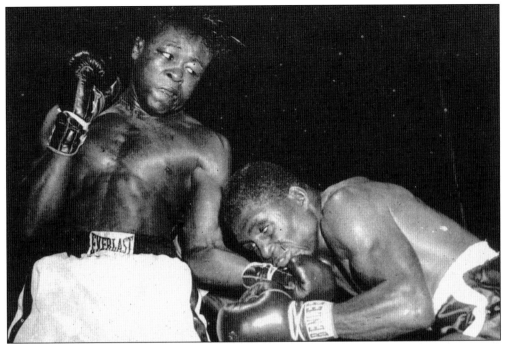

SAXTON BEATS GAVILAN. Welterweight Johnny Saxton (right) ends the three-year championship reign of the "Cuban Hawk." Saxton, shown here ducking into Kid Gavilan's famous bolo punch, stunned the crowd at Convention Hall when he was awarded the 15-round decision and the welterweight championship on October 20, 1954.-Saxton, a local favorite, never fought in Philadelphia again.

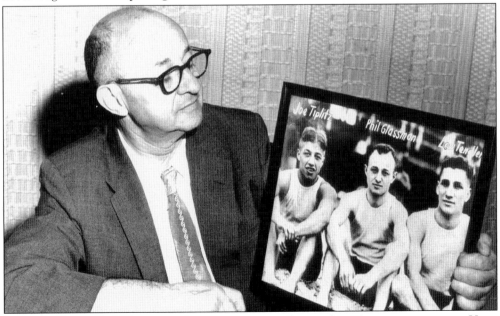

LOOKING BACK. Phil Glassman takes a moment to reflect on his 45 years as a manager. Here, he looks at a photograph of Joe Tiplitz, himself, and Lew Tendler. (Courtesy Temple University Libraries, Urban Archives.)

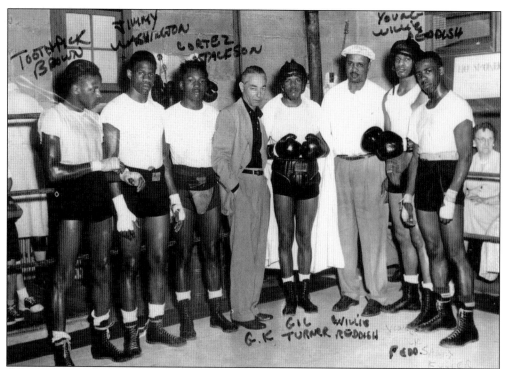

THE KATZ STABLE. Shown here are George Katz (center) and some of his fighters. With Katz, from left to right, are Toothpick Brown, Jimmy Washington, Cortez Jackson, Gil Turner, Willie Reddish, Young Willie Reddish, and Sammy Fuller. (Courtesy Antiquities of the Prize Ring.)

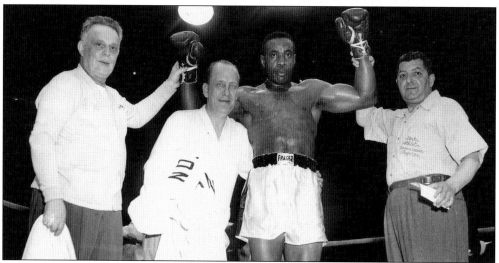

WHAT A TEAM! Arguably Philadelphia's greatest trainer and cut man, Jimmy Wilson (Vincent Silvano) (second from the left) hugs his new protégé, Sonny Liston, after Liston stopped Julio Mederos in three rounds in Chicago on May 14, 1958. Unfortunately, Wilson, who trained all of Frank "Blinky" Palermo's boxers, suffered a heart attack and died eight months later. Liston remained a Philadelphia resident until he won the heavyweight title from Floyd Patterson in 1962. (Courtesy George Silvano, son of Jimmy Wilson.)

106

CHAMPS GYM. Perhaps the most famous gym in Philadelphia boxing history was Champs, located in Strawberry Mansion. Pictured, from left to right, are Von Clay, Len Matthews, J.D. Ellis (in front), Georgie Benton, and Don Warner.

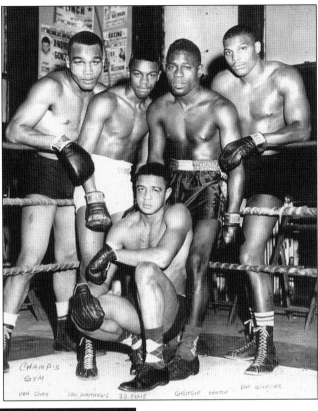

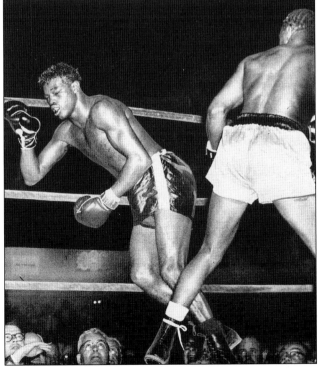

A RED-HOT BATTLE. Garnett "Sugar" Hart (left) was a tall, rangy boxer-puncher from Strawberry Mansion in North Philadelphia who, in the early 1950s, was compared to Sugar Ray Robinson. He was a top contender when he met Charley Scott at Convention Hall on October 19, 1959, in one of the fiercest battles in local boxing history. Scott stopped Hart in the ninth round. Writer Stan Hochman described the action as "two men fighting for their life on the edge of a cliff." Neither fighter was ever the same after the punishment they endured in this epic struggle. (Courtesy Peltz Boxing Promotions Inc.)

GEORGIE BENTON. Uptown North Philadelphia legend Georgie Benton was avoided by most of the top middleweights during his career. His fight with future champion Joey Giardello at Convention Hall in 1962 was an all-time Philadelphia classic. Benton later became one of the sport's most respected trainers. (Courtesy Antiquities of the Prize Ring.)

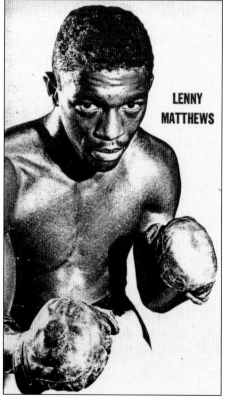

LENNY MATTHEWS

A CAN'T-MISS PROSPECT. Lenny Matthews came on the professional boxing scene in Philadelphia in 1957. He hailed from the Strawberry Mansion section of North Philadelphia and had everything. Tall and lean, trigger-fisted with terrific power in both hands, he had already made an impression on boxing people and fans long before he turned professional. After a brilliant start to his career, Matthews ran into some unfavorable decisions but worked his way up among the top contenders. A couple of losses to Carlos Ortiz and Willie Toweel (1959) and Doug Vaillant (1960) ended his hopes for the title.

Eight

1960–1969

Harold Johnson, Sonny Liston, and Joey Giardello finally hit championship pay dirt in the 1960s. Johnson won the vacant National Boxing Association (NBA) light heavyweight title in 1961. Liston destroyed heavyweight champion Floyd Patterson in one round in 1962. In 1963, Joey Giardello outboxed middleweight champion Dick Tiger.

Marty Kramer began regular shows at the Blue Horizon Ballroom in North Philadelphia in 1961, and Georgie Benton revived his career fighting there.

In 1963, Johnson lost his title to Willie Pastrano, and Giardello lost his to rival Dick Tiger. Liston was upset by young Cassius Clay (Muhammad Ali) in 1964.

Stanley "Kitten" Hayward, Bennie Briscoe, Leotis Martin, "Gypsy Joe" Harris, and 1964 Olympic heavyweight champion Joe Frazier were causing excitement.

Showboating Harris quickly became the biggest attraction with his 24 wins in a row, including a stoppage of Hayward and a victory over welterweight champion Curtis Cokes. However, he lost to Emile Griffith and was forced to retire when it was discovered that he was blind in one eye.

Soon afterward, Hayward defeated Griffith and became the top middleweight contender, but his fast lifestyle soon slowed the Kitten.

Joe Frazier's blistering, explosive left-hooking style caught the eye of sports fans at the 1964 Olympics. Muhammad Ali, who defeated Liston for the crown, was stripped of his title for refusing the draft in 1967.

Frazier was managed by a corporation of Philadelphia businessmen. He soon proved to be the best in the game. He won the New York version of the world title and, in 1968, became the undisputed world heavyweight champion.

Hard-punching Leotis Martin attained the No. 1 ranking by knocking out Liston in 1969 but suffered a detached retina and retired.

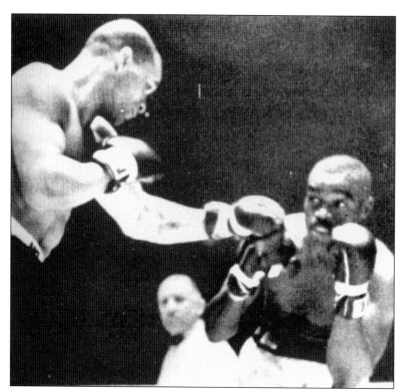

JOHNSON KEEPS THE TITLE. Harold Johnson stopped Jesse Bowdry in nine rounds on February 7, 1961, at Miami Beach to win the world light heavyweight championship. On May 12, 1962, Johnson (left) fought Doug Jones (right) at the Philadelphia Arena and won a 15-round decision in his third defense of the title.

A GOOD TEAM. From left to right are Sonny Liston, reporter John Bruen, and trainer Willie Reddish. Liston got solid advice from Reddish, who was a good influence in his life. Bruen was able to do the inside story because of his friendship with the two. (Courtesy Antiquities of the Prize Ring.)

A BAD MAN. Sonny Liston
finally got a title shot at Floyd
Patterson and the heavyweight
championship on September 25,
1962, in Chicago. Liston finished
off Patterson in two minutes
and six seconds of round one to
capture the crown. Ten months
later, on July 22, 1963, in Las
Vegas, he did it again in two
minutes and ten seconds.

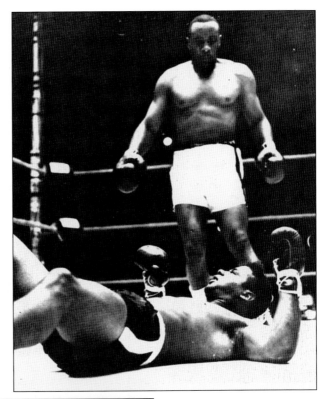

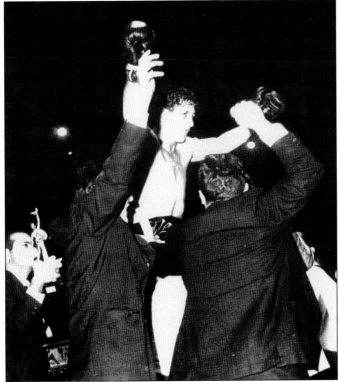

A LONG WAIT. After
being a top-rated
middleweight for 11 years
of his 15-year career, Joey
Giardello finally won the
middleweight championship
on December 7, 1963,
at Atlantic City when
he defeated Dick Tiger
in 15 rounds. No matter
how talented the foe,
black or white, Giardello
never ducked a deserving
opponent during his
career. He risked his rating
and enabled many to earn
the largest paycheck of
their career.

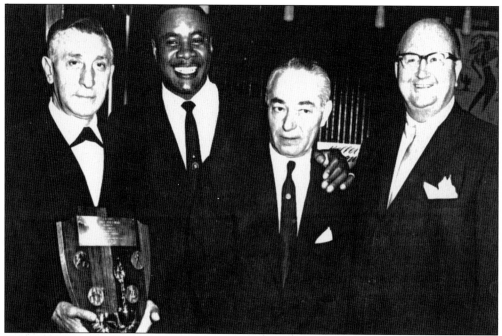

HAVING A GRAND TIME. Pete Tomasco (left), top Philadelphia referee for more than 40 years, stands next to Sonny Liston and his new manager George Katz, who was hired to polish Liston's image. Katz had piloted Gil Turner to the top echelon. On the right is Pinny Schafer, who teamed with Pat Duffy to manage such local stars as Jimmy Soo, Bennie Briscoe, Sammy Goss, Leotis Martin, "Boogaloo" Watts, and Bob Cofer.

BAD BENNIE. Bennie Briscoe, a Georgia man who came north to Philadelphia, was a regular at the Philadelphia fight clubs and a favorite of the crowds.

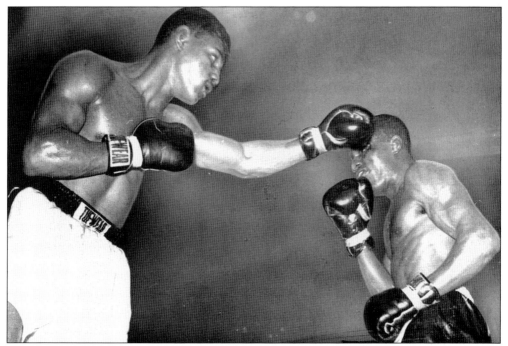

WHAT A KITTEN. Kitten Hayward was an excellent boxer who worked his way to the top and knocked off some good men. Hayward is seen jabbing Dick Turner on January 20, 1964, at the Philadelphia Arena. Hayward defeated former middleweight champion Emile Griffith on October 29, 1968, in Philadelphia but lost a return match in New York on May 12, 1969. He lost a junior middleweight title bout to Fred Little on March 17, 1969, in Las Vegas. (Courtesy Temple University Libraries, Urban Archives.)

THE RING WIZARDS. When Muhammad Ali defeated Sonny Liston to win the heavyweight championship on February 25, 1964, at Miami Beach, in his corner was Angelo Dundee (Mirena) (right) a cagey boxing genius. Philadelphia born, Dundee also tutored other great fighters, such as Ray Leonard, Jose Napoles, Pinklon Thomas, Slobodan Kacar, Michael Nunn, and George Foreman. His brother Chris (left) managed many fighters and promoted many bouts during a long career associated with boxing. Ali and both Dundees went on to be elected to the International Boxing Hall of Fame. (Courtesy Antiquities of the Prize Ring.)

THE GIARDELLO-CARTER TITLE FIGHT.
Here is the program for the Joey Giardello–Rubin Carter middleweight championship bout held on December 14, 1964, at Convention Hall. Giardello boxed well and earned a decision over Carter.

LARRY MERCHANT ON THE GIARDELLO-CARTER FIGHT.
A next-day report written by Larry Merchant, now of HBO fame, supports the Giardello win and tells a different story than the one presented in the recent movie *The Hurricane*.

Larry Merchant

Carter Knew His Best Just Wasn't Good Enoug

It was a story as old as anything. One man's best was better than another man's best. Joey Giardello beat Rubin Carter.

That was the story of the fight at Convention Hall last night and now Rubin Carter was trying to explain why his best wasn't the best, why Joey Giardello is still middleweight champion. At first he protested, mechanically rather than vehemently—"The other fighter says [he] thinks he won"—but gradually it became apparent that he knew his best just wasn't good enough. Not good enough to take a title away from somebody anyway.

"I fit the fought," Rubin Carter said. He started over again. "I fought the fit." One more time. "I fought the fit he wanted me to fight." He turned to his manager, [Carmine] Amato, with a grin. "Are you sure I wasn't hit?" [he] wondered.

And that was the story too. Joey Giardello arranged the choreography of the [fig]ht, arranged it for Joey [Gi]ardello's benefit, and [poor] Carter was helpless [to] change it for Rubin [Car]ter's benefit.

"Who says I'm old?" said Joey Giardello. "I've [been] in enough fights to [kno]w how to fight, and as [long] as they let me set the [pace] I'll fight 'til I'm 50."

The pace-setter went [int]o the ring with an im[pre]ssive catalogue of pluses—experience (126 fights to [78] fights), skill, the cham[pion]ship, the home town. [Car]ter had a couple of [thin]gs going for him as [well]: age (27 to 34) and [str]ength. Giardello used all of his pluses. Carter didn't [use] all of his.

"I wanted to hit him in the first round," Giardello [sai]d. "I wanted to see what kind of chin he had, and I [wan]ted him to know I could hit him." He used the same [for]mula to win the championship from Dick Tiger.

Preconceived Respect

Carter danced Giardello's dance after that, a dance [ec]onomical and venerable as the peabody. The challeng[er], who should have been coming on with the frug or [som]ething, danced it not because any one punch dis[cou]raged him, but because of a preconceived respect [tha]t was confirmed in the early rounds. Carter didn't [hav]e the boxing ability to cope with a classic counter[pun]cher like Giardello, and he didn't have the resolve [to] rumble.

The control Giardello had of the tempo was illustrat[ed] in two rounds, the fourth and the eleventh.

In the fourth Carter opened a hairline cut alongside [Gi]ardello's left eye with a butt. The sight of blood seemed [to] embolden Carter, but only momentarily. He resumed his [da]nce stalking from a well-protected front. His jab [was] not sharp enough or busy enough to keep the cut [op]en after that. "He looked like he was trying to rely on [a] knockout punch," Giardello said.

In the eleventh, as in the tenth, the champion was

obviously coasting. He had the lead and he was preserving himself for the last four dances. Carter didn't press him. "I expected him to tear after me," Giardello said.

This failure to extend himself and Giardello put Carter back on the middleweight stag line. "I could have gone another 15," Carter said. He should have put his surplus energy to work in the first 15. Giardello took three of the last four rounds.

What could Carter possibly have been thinking of? By his own admission: "Nothing. I just wanted to hit him." And the rationale: "If I chased him anymore he would have run up on the roof."

'I Had to Knock Him Down'

Having come this far from his dark twisted youth, and aware in his own words "that I knew what would happen from the way they were talking" and "I had to knock him down"—allusions to the truth that he couldn't win a decision anywhere near close—why hadn't he jumped in with both feet?

"I didn't want to get anxious," Carter said. "He's taken some pretty good punches from some pretty good fighters. There's such a thing as punching yourself out." Would he do it the same way again? "If somebody gets hit by a car they wouldn't cross the street again would they?"

He answered that on himself. They would. "It looks easy from the outside," Rubin Carter said. "I was trying to beat him the best way I could."

His best just wasn't good enough.

HEAD-TO-HEAD—Rubin Carter brings head into con[tact] with Joey Giardello's chin in close action

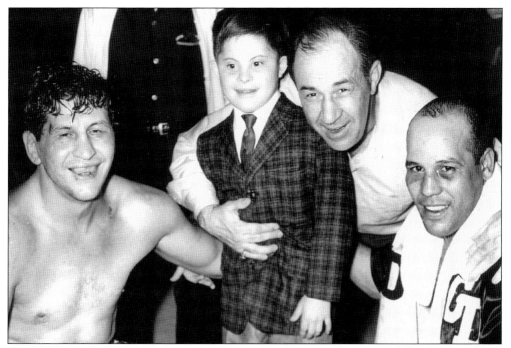

THANKS FOR WINNING, DADDY. Middleweight champion Joey Giardello (left) and Gil Diaz pose with Giardello's son Carmine after they boxed a benefit for the St. John of God School for Special Children in April 1965. Giardello donated his purse and all proceeds to the school in which Carmine was a student. Giardello devoted much of his time to raise funds for special children.

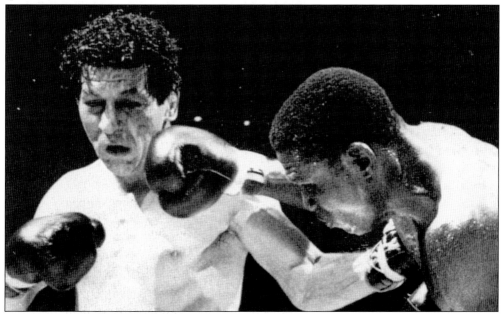

TIGER REGAINS THE TITLE. Joey Giardello (left) exchanges punches with Dick Tiger in a losing effort at Madison Square Garden on October 21, 1965. Tiger won a 15-round decision to recapture the middleweight championship.

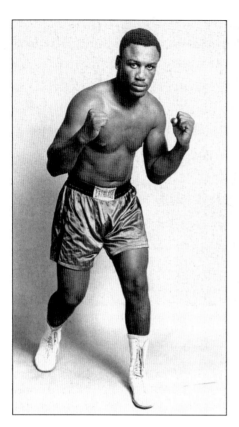

SMOKIN' JOE. Joe Frazier, born in South Carolina, made Philadelphia his fighting home and won the world heavyweight championship during his career. Frazier, rated among the best heavyweights ever, engaged in three outstanding bouts with Muhammad Ali.

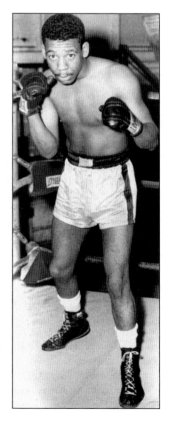

A VERY GOOD FIGHTER. Welterweight Marvin "Candy" McFarland defeated two world champions in 1960: Don Jordan on May 16 at Baltimore and Virgil Akins on December 6 at Convention Hall. On October 21, 1967, Candy lost a terrific 10-round decision to Luis Rodriguez at Caracas in a close fight. McFarland broke his right hand in round one.

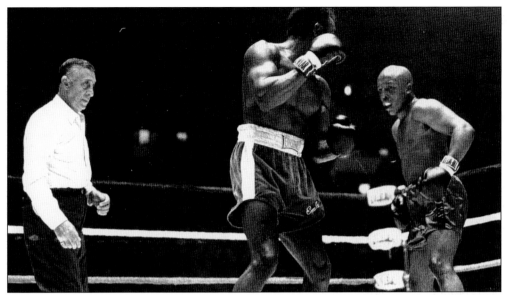

HARRIS SUFFERS HIS FIRST LOSS. Gypsy Joe Harris (right) of North Philadelphia was a big attraction with his showboating style and his 24 wins in a row. This streak included a stoppage of Kitten Hayward at the Philadelphia Arena and an easy victory over the welterweight champion, Curtis Cokes, at Madison Square Garden in 1967. Harris experienced his only setback when he was outmaneuvered by the great Emile Griffith (above) on August 6, 1968, at the newly opened Spectrum before 13,875 fans. Harris was forced to retire soon afterward when the commission "discovered" that he was blind in one eye. (Courtesy Rich Pagano.)

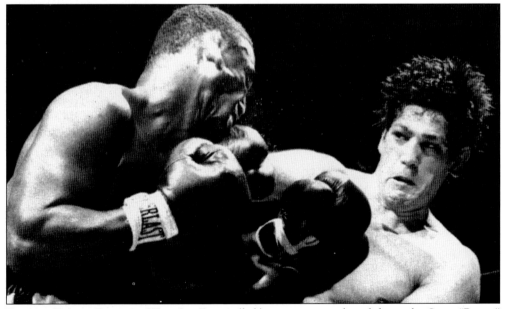

FRAZIER FIGHTS BACK TO WIN. Joe Frazier (left) overcame two knockdowns by Oscar "Ringo" Bonavena in their first fight to win the decision at New York on September 21, 1966. Here, he posts a solid win at the Spectrum to retain his version of the heavyweight championship in a 15-round decision on December 10, 1968.

A REVIVAL. The Blue Horizon was purchased by longtime boxing and entertainment entrepreneur Jimmy Toppi. In 1961, Marty Kramer promoted the first in a series of fight shows there. In 1969, 22-year-old J. Russell Peltz inaugurated a biweekly boxing program at the long dormant Blue Horizon that helped usher in a fistic boom in Philadelphia. In a few years, the Blue Horizon became America's favorite neighborhood fight club due to its intimate old-time atmosphere. It was shown nationally on Tuesday night fights on the USA network and continued on the ESPN Friday night series.

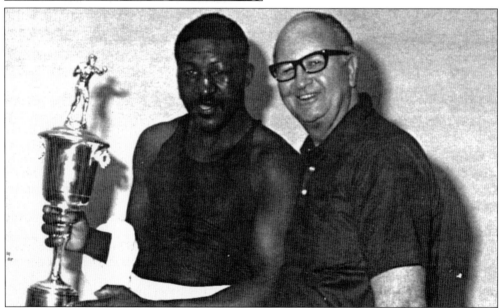

A SHARP HITTER, A PROUD WINNER. Leotis Martin was a top heavyweight contender from 1967 to 1969. On August 5, 1967, in Houston, he fought Jimmy Ellis in a World Boxing Association (WBA) heavyweight elimination bout and lost in nine rounds. In an upset victory over Sonny Liston, he won the North American Boxing Federation (NABF) heavyweight championship on December 6, 1969, in Las Vegas. Martin is shown here holding his NABF trophy alongside manager Pinny Schafer. Ironically, Martin's greatest victory was his last. He suffered an eye injury and was forced to retire.

Nine

1970–1976

On February 16, 1970 at Madison Square Garden, Joe Frazier won universal recognition as heavyweight champion when he demolished Jimmy Ellis, who could not come out for the fifth round. The public now clamored for a match between Frazier and Muhammad Ali, whose license had been restored. Ali was staging a comeback with victories over Jerry Quarry and Oscar Bonavena. Frazier met and defeated Ali in the "Fight of the Century" in 1971.

Peltz's Blue Horizon paid dividends as many top boxers were developed. Excellent matchmaking and outstanding performances made Boogaloo Watts, Willie "the Worm" Monroe, "Cyclone" Hart, Sammy Goss, and Perry L'il Abner household names. Bennie Briscoe's career was revived.

Marvin Hagler's campaigns in Philadelphia brought him worldwide attention. He suffered two defeats here and later avenged them. Hart's terrifying left hook, Briscoe's brutal body attack, and slick boxing by Watts, Monroe, and Kitten Hayward added sizzle to the Philadelphia scene. Only Briscoe secured title shots, but he was unable to win the trophy.

One of the best boxers of this time was Tyrone Everett, who possessed remarkable skills. He ranked among the best and won some great battles. He lost only 1 bout in his 37-bout career—the controversial decision to Alfredo Escalera. Everett was shot and killed in an untimely death.

Frazier lost his crown on January 23, 1973, to the brutish George Foreman but fought his way back into contention against Ali in the "Thrilla in Manila" in 1975.

To many observers, it seemed that Jimmy Young outboxed Ali in 1976 at Landover but was declared the loser in a stunning decision. Later, Young won some magnificent victories but experienced some more questionable losses.

The success of the Spectrum programs launched a boxing boom, and fight clubs sprang up all over. From these came Matthew Franklin and Mike Rossman. Franklin's bouts against Marvin Johnson, "Dynamite" Douglas, Richie Kates, and Yaqui Lopez were classics. However, the emergence of casino gambling in Atlantic City gradually forced Philadelphia out of big-time boxing promotions.

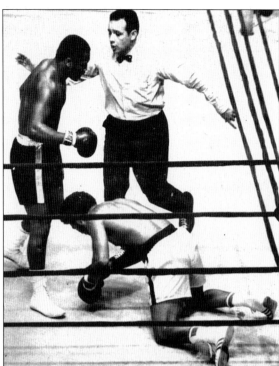

FRAZIER DEFEATS ELLIS. Joe Frazier (left) unified the heavyweight championship against Jimmy Ellis on February 16, 1970, in New York. Frazier stopped Ellis in round five.

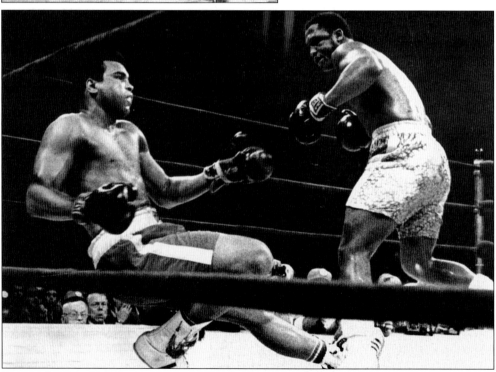

DOWN GOES THE BIG MAN. Joe Frazier floors Muhammad Ali in round 15 of their great bout at Madison Square Garden on March 8, 1971. Frazier took a 15-round decision to retain his title.

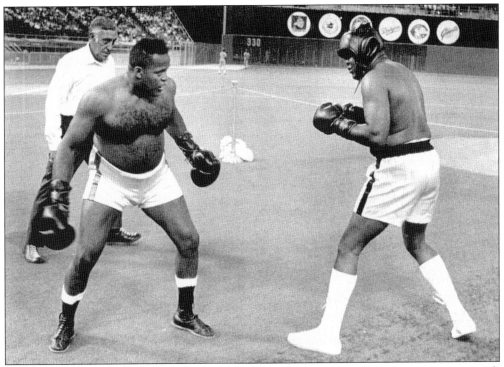

An Ali-Turner Sparring Session. Gil Turner, former welterweight sensation, spars with then Philadelphia resident Muhammad Ali (right) as they help open the new Veteran Stadium. Referee Pete Tomasco looks on. (Courtesy Rich Pagano.)

Timber-r-r-r. Muhammad Ali threatens to whack Wilt Chamberlain if he does not keep his distance. Chamberlain is laying down some "law" to Ali. There was talk in the early 1970s about Chamberlain meeting Ali in the ring. Ali said that if he ever got in the ring with him, Chamberlain would never play basketball again. (Courtesy Antiquities of the Prize Ring.)

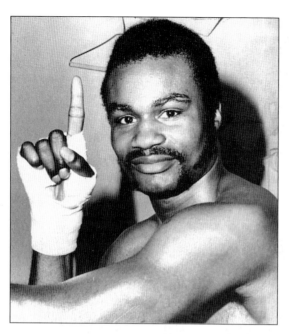

A MIGHTY FINE FIGHTER. Eddie Gregory, who changed his name to Eddie Mustafa Muhammad, started his ring career in 1972 in New York and built up a nice 13-1-1 mark by the time he fought Bennie Briscoe in Philadelphia on August 18, 1975. Briscoe won that one in 10 rounds. Gregory overcame the setback and went on to win the light heavyweight championship of the world a few years later. (Courtesy the Ring.)

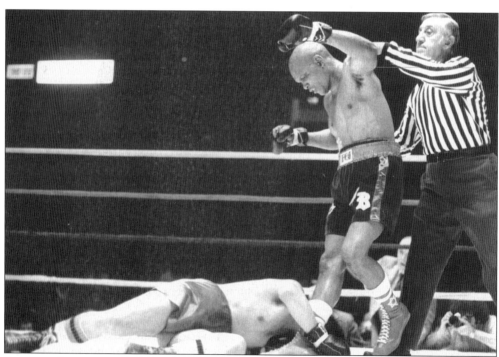

BENNIE SCORES A KNOCKOUT. Bennie Briscoe, a real crowd pleaser, knocked out Art Hernandez at the Spectrum on March 26, 1973, to win the North American middleweight championship.

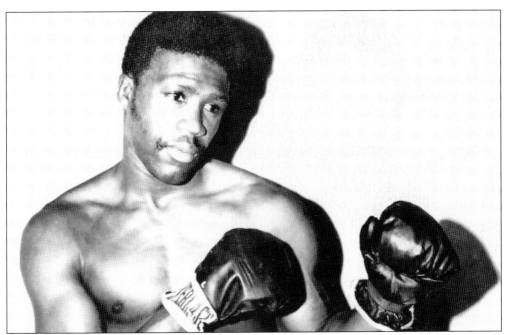

A TALENTED BOXER. Sammy Goss, featherweight–junior lightweight, was born in Trenton but fought most of his bouts in Philadelphia. Goss was a good boxer with a good punch. He beat Lloyd Marshall for the North American featherweight title in 1971 and Jose Fernandez for the American junior lightweight title in 1973.

YOUR HEART SOUNDS GOOD. Two ace Philadelphia fighters are joking around. Willie "the Worm" Monroe checks Stanley "Kitten" Hayward's heart and determines that he is in good shape. Monroe beat Hayward a few days later, on April 7, 1974, at the Spectrum. (Courtesy Temple University Libraries, Urban Archives.)

A GOOD START, A GOOD MAN. Mike Rossman began his career in 1973 and,-by 1976, built a 28-3-3 record with 16 knockouts. During this time, he defeated such men as Tyrone Freeman, Nat Dixon, Matt Donovan, Al Styles, and Mike Quarry. Rossman went on to win the light heavyweight championship and defended it once in a Philadelphia ring. (Courtesy Antiquities of the Prize Ring.)

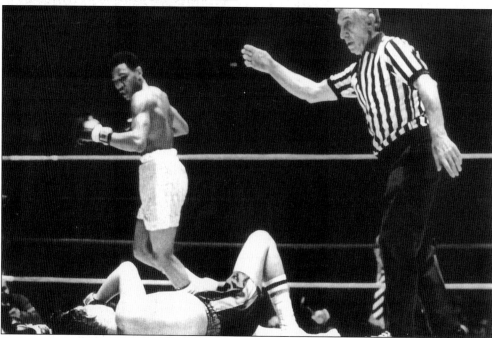

A GIFTED FIGHTER. Tyrone Everett was possibly the greatest Philadelphia boxer developed during the Spectrum era. He had no peer during his brief but brilliant career. He could do everything that champion Pernell Whitaker could do, and Everett was a harder puncher. A terrific attraction at the Spectrum occurred on November 30, 1976, when the undefeated South Philadelphian lured dangerous junior lightweight titlist Alfredo Escalera to town. A record Pennsylvania indoor crowd of 16,000 turned out for a championship showdown. The receipts of $204,000 were also a record. Everett completely outpunched Escalera only to lose what most witnesses considered an unjust decision. Just a few months later, he was tragically shot to death by a jealous lover. This photograph was taken of his knockout win against Jose Luis Lopez at the Spectrum on March 11, 1975.

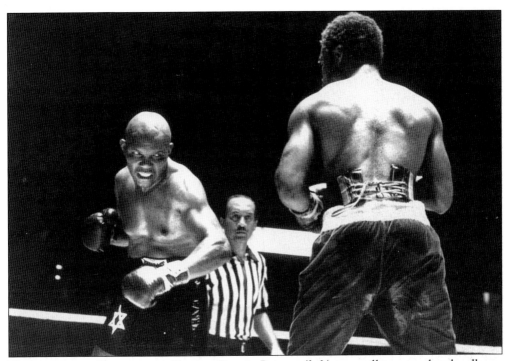

YOUTH VERSUS EXPERIENCE. Veteran Bennie Briscoe (left) was still too tough a hurdle on August 18, 1975, at the Spectrum for even such a talented youngster like Eddie Gregory. Briscoe won a 10-round decision. (Courtesy Peltz Boxing Promotions Inc.)

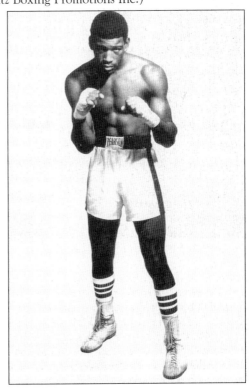

A GOOD HITTER. Matthew Saad Muhammad, formerly Matthew Franklin, was a Philadelphia fighter who experienced a good beginning to his career. From 1974 to 1976, he compiled a 13-2-2 record with seven knockouts against some quality competition such as Wayne Magee, Roosevelt Brown, Harold Carter, Mate Parlov, and Marvin Camel. He eventually became light heavyweight champion and a Hall of Famer. (Courtesy Antiquities of the Prize Ring.)

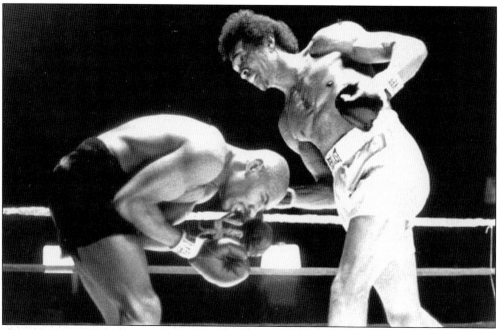

WELCOME TO PHILADELPHIA. Willie "the Worm" Monroe digs a right to the head of Marvin Hagler as he ducks. This bout was held on March 9, 1976, at the Spectrum. Hagler lost this bout in 10 rounds but later avenged himself against Monroe. (Courtesy Peltz Boxing Promotions Inc.)

A CLEVER PHILADELPHIA FIGHTER. Jimmy Young began boxing in 1969. After a 7-4 start, including a knockout loss to Earnie Shavers, Young developed into a wonderful boxer and defensive wizard who earned victories over Richard Dunn, Jose Luis Garcia, Ron Lyle, Al Jones, and Jose "King" Roman. On April 30, 1976, Young boxed Muhammad Ali for the heavyweight championship at Landover, Maryland, in a controversial bout, which many observers thought he won. This was one of the peak performances of his career. (Courtesy Peltz Boxing Promotions Inc.)

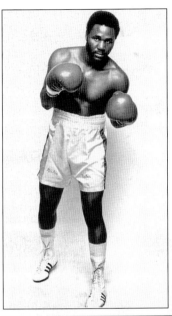

THE MAN FROM MILLVILLE. Richie Kates hailed from New Jersey and was a Philadelphia favorite who became a top-rated light heavyweight. He was robbed of winning the world title from Victor Galindez on May 22, 1976, at Johannesburg when the fight was delayed 20 minutes in order to repair Galindez's wounds, instead of awarding the crown to Kates. Galindez went on to win the contest in the 15th round, but Kates remained highly ranked and boxed the best men in his division for many years. (Courtesy Peltz Boxing Promotions Inc.)

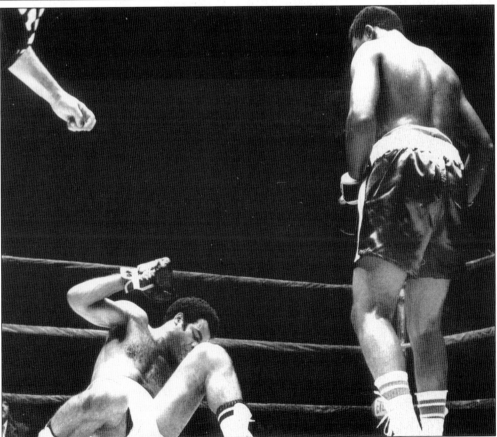

DOWN YOU GO. Jimmy Young drops Lou Rogan for keeps at the Philadelphia Arena on September 2, 1976. (Courtesy Temple University Libraries, Urban Archives.)

127

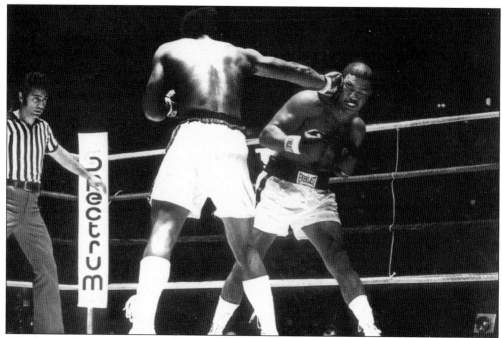

MARVIN JOHNSON. Indianapolis native Marvin Johnson (left) scored a sensational one-round knockout of Wayne Magee on the undercard of the Marvin Hagler–Cyclone Hart bout at the Spectrum on September 14, 1976. Johnson signed with local promoter J. Russell Peltz and became a Philadelphia favorite and two-time light heavyweight world champion. His first contest with Matthew Franklin (Saad Muhammad) at the Spectrum is considered one of Philadelphia's greatest action fights. (Courtesy Peltz Boxing Promotions Inc.)

RECOGNIZE THIS GUY? Rocky Balboa (Sylvester Stallone) personified the image of the Philadelphia fighter in his *Rocky* movie series. Here, he pounds the bag in his undying determination to be the best. It was no surprise that Philadelphia, with its strong reputation for aggressive and relentless fighters, was selected as the home base for the *Rocky* movies. (Courtesy Antiquities of the Prize Ring.)